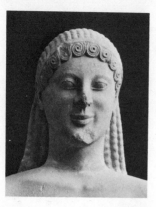

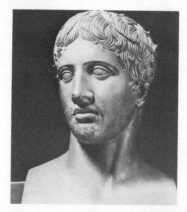

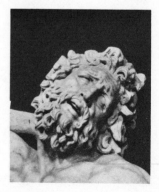

Frontispiece: details from
three Greek statues; an Archaic
Kouros ("Apollo"), the Classical
Doryphorus, the Hellenistic
Laocoön and his Sons.

STYLE
IN ART HISTORY

An Introduction to
Theories of Style and Sequence

by

MARGARET FINCH

The Scarecrow Press, Inc.
Metuchen, N.J. 1974

Library of Congress Cataloging in Publication Data

Finch, Margaret, 1932-
 Style in art history.

 Bibliography: p.
 1. Art--Philosophy. 2. Aesthetics. 3. Art--
Psychology. I. Title.
N71.F56 701 73-14705
ISBN 0-8108-0679-7

ACKNOWLEDGMENTS

My gratitude is expressed to the late Robert Goldwater, my advisor at the Institute of Fine Arts, who encouraged this project. I want also to thank A. Elizabeth Chase, a former professor of mine at Yale, who edited the manuscript. Further, I am indebted to many friends who have had the kindness to read the manuscript and offer suggestions.

For their advice and help in assembling photographs, I want to thank my department chairman, Eleanor Dodge Barton, and the slide librarian at the University of Hartford, Jerome Wolf; also Ann Byford of Scala-New York. The acquisition of photographs was made possible by the Vincent Brown Coffin Grant of the University of Hartford and a Shell Company Foundation Grant.

PREFACE

This text attempts to reformulate for the art history student some traditional and current ideas about style and sequence. It puts into context portions of the thinking of pioneers in the theory of styles, Bernard Berenson, Alois Riegl, Heinrich Wölfflin, and Wilhelm Worringer, who wrote over a half century ago. Certain ideas that have withstood the eruptions of new-found information about the past and the bombardment of twentieth-century styles have been singled out and revised to meet students' needs. Also, the text brings the topic up to date by including some contributions made toward mid-century by Sir Herbert Read, Henri Focillon, Erwin Panofsky, Meyer Schapiro, and others; and it turns to some recent ideas of James Ackerman, George Kubler, and especially Sir Ernst Gombrich.

Theories about classifications for art are again coming into favor after a half century of relative neglect. The turning point was perhaps in 1953 when Schapiro reviewed past ideas in an article called "Style" and concluded that there was a need for a modern theory of style. Others such as James Ackerman, in an article of 1962 titled "A Theory of Style," contributed to this shift by urging fresh thinking about style. As though in response to such pleas, Gombrich's Art and Illusion in 1960 and Kubler's The Shape of Time of 1962 made the first major contributions to the field since Wölfflin and Worringer.

It is true that the intermediate generation of Read, Focillon and Panofsky had a philosophical bent, but the times did not seem ripe for generalization of the sort that requires the grouping together of art works. Indeed, there was an overriding fear of what Panofsky termed any "systemizing or generalizing method which treats the unique work and artist as if they were merely specimens."[1] Because of "the prevailing antitheoretical mood," as Ackerman expressed it, art history seemed headed toward the opposite extreme

of excessive particularization and "narrow scientism."
Then, as I see it, Gombrich and Kubler helped to restore
balanced development.

The recent philosophical trend in scholarly thought
is made accessible to students in this volume. It is the
author's feeling that a theoretical approach will prove
especially meaningful to the student. A general schema
allows one to view the whole sweep of art history within
which individual works of art, as they emerge, bear some
relationship to those works that precede and to those that
follow. Such a view helps one to organize and classify
one's knowledge. Furthermore, because of the perspective
enabled by a broad view, one actually gains an added means
for deep appreciation of the unique work and the unique
artist.

The text tries to strike a fair balance between the
study of meaning (iconology) and the study of form (mor-
phology). While giving Panofsky's "intrinsic meaning" its
place, it must be acknowledged--taking a cue from Kubler--
that special attention has been devoted to form theories to
compensate for neglect in recent years. Also, consider-
able attention has been given to the matter of representa-
tional art versus abstraction, and Gombrich's research into
pictorial illusion has been relied upon in this case. At
first, the author's role was planned to be largely that of
conciliator, but the process of synthesis continually generated
fresh insights. The volume took shape as something differ-
ent from a simple digest of major sources, being extremely
selective and admitting to recasting certain ideas in new
settings. The reader is urged to go from this introductory
consideration of style and sequence back to the authorities
and, what is more, to dare his own reformulation of the
ideas tested here.

CONTENTS

vii

Chapter I

STYLE AND SEQUENCE

When you see a painting by van Gogh, any painting, the chances are you can guess the name of the artist without being told. Whether the subject depicted is a portrait, a wheatfield, or a vase of flowers; whether the underlying attitude is lighthearted or troubled; you can recognize certain characteristics that are peculiar to van Gogh's work. Just what traits, specifically, do you recognize? For one thing, you may notice that the painting is done with very bold brush strokes, and you may happen to know that this type of brushwork is typical of van Gogh. This distinctive brushwork identifies the work for you as clearly as a signature. In this case, you can say you have recognized van Gogh's style.

Style may be defined as those distinctive characteristics that enable the observer to link an art work with other works. There are fundamentally two types of style; these are an individual's personal style, and the style common to a group of artists. In other words, the distinctive traits in a work of art enable the observer to link an art work with other works by the same artist or with other works by a different artist.

An individual's style betrays the identity of the artist. An informed observer, even when confronting an unfamiliar painting, can identify a van Gogh canvas by means of certain characteristics. In his mind, the observer might connect the painting in question with other works by van Gogh that have similar vigorous brush strokes; he might associate the painting with other works having similar colors; or he might instinctively react to the total effect of brush strokes, colors and a number of other factors.

A group's style betrays a general artistic climate. When studying a van Gogh painting, a casual observer

might say to himself, "The brushwork reminds me of painting
of the French school in the nineteenth century." That is,
the conspicuous brush strokes might enable him to link the
painting in question with other works by different artists.
Even the expert might need to resort to such a group desig-
nation if tested by a small detail from a van Gogh painting.
Sometimes, Delacroix, Renoir, or Cezanne have similar
strokes--all of these painters belong to the category of
artists working in France in the nineteenth century.

In the same way, when contemplating any Greek
temple an observer might say to himself, "This building
looks very much like the Parthenon." That is, the general
appearance of the columns and the organization of the parts
of one Greek temple relate it to another temple by a differ-
ent architect. Indeed, merely the foundation in ruins of
such a building provides the architectural historian with
enough evidence to recognize a Greek temple. In this case,
identifying characteristics have nothing to do with an artist's
personal mannerisms nor with shop techniques. The Greek
culture had a quite definite idea about what a temple should
look like, and builders of temples naturally conformed to
the accepted formula. Since most groups' styles are simi-
larly rooted in a common background, they are often
labeled according to the date or place of their origin.
More descriptive headings for groups' styles are those
based on the particular traits shared by the members of the
group.

You may say, "What type of distinctive character-
istics make it possible to link an art work with other works?
Which traits are most appropriate in different cases?"
The questions are good ones. So far, the present discus-
sion has been limited to a few examples--brushwork and
color with van Gogh, organization of parts in the case of a
Greek temple--but there are naturally innumerable other
relevant factors within the realm of possibility. In fact,
knowing what particular characteristics are most valid and
helpful in a given situation is of utmost importance. This
is not as difficult as it might seem at first; the sense of what
is most significant comes gradually to the student of art
history through exposure to art; and the problem is simpli-
fied by the fact that all distinctive factors in all works fall
into one of three categories.

All characteristics in works of art pertain to one
of the following: form; subject matter; meaning. The

purpose of this book is to develop some ideas about these topics that will be helpful in organizing your thoughts about art works. An awareness concerning them should increase your sensitivity to the matters of style. By way of introduction, form, subject, and meaning will be defined briefly below. The ideas introduced in the following definitions and related ideas will be developed in the succeeding chapters.

Form: how a painting is done concerns form. All aspects of composition and technique are form in this broad sense of the word. Most simply, form consists of line, shape, and surface texture and color. Brushwork (which has already been mentioned) is an aspect of the last category--surface. Since in van Gogh's case the handling of the brush is distinctive, it is possible to guess that he is the artist of a painting by observing the brushwork. Then, van Gogh's style has been identified through an aspect of form. As a matter of fact, one may usually find identifying characteristics--style--by studying the form of an art work.

Subject matter: the subject is what is painted. A subject may be realistic or abstract. In the first paragraph, when mentioning various subjects, "a portrait, a wheatfield, or a vase of flowers," the examples were images taken from everyday experience. However, subject matter in art need not be real objects; the role of abstract art will be subsequently developed. In van Gogh's case, the image of a cypress tree beside a wheatfield in an unfamiliar painting is a clue to the identity of the artist. Subject matter happens to be significant to van Gogh's style because certain subjects are typical of him.

Meaning: this refers to the underlying attitude. For example, when deciding whether a work appears "lighthearted or troubled" (to use a phrase employed initially), the topic under consideration is meaning. Actually, two concepts are embraced under this heading. Meaning may be thought of as comprising both the artist's original idea and the outward evidence of the idea in the resulting work; both the artistic "intention" and the "content" in art. Artistic intention (or volition) is why a work is undertaken; content (sometimes theme or expression) is the resulting manifestation of the intention in a tangible object. The meaning is transformed by the process of execution. The finished art work necessarily emerges as a modification of the original intent, partly because the idea was at first formless in

a very real sense; when the idea took a form, it was inevit-
ably affected by the character of the medium. This explains
one distinction between the artist and the craftsman. The
artist may begin with a vaguely-sensed evolving idea that de-
velops as the work progresses, whereas the craftsman en-
joys no such flexibility nor suffers such uncertainty."[1]

Various basic types of meaning may be classified,
ranging from the ritualistic to the emotive. Along this
scale, van Gogh, in his seeming spontaneity, subscribes to
the latter inclination. Since this attitude is characteristic
of his work, it is part of what is called his style.

Style is any factor pertaining to form, subject, or
meaning which is sufficiently constant in a group of art
works to establish a relationship among the works. Subject
matter and meaning sometimes contain traits that are dis-
tinctive enough to be reliable indicators of style. By them-
selves, however, subject matter and meaning are usually in-
adequate gauges. By far the most significant factors in
identifying the artist of a work or in locating a work as to
date and place involve how the subject is handled and how
the meaning is conveyed. Form is the most reliable clue
to the artist's or the group's identity. Form usually betrays
identifying characteristics--style--no matter what the subject
or meaning may be. Because of the connection between
form and style, the assumption that the two are virtually
synonymous is common. Seeking balance, this volume tries
to show how subject and meaning may also contribute in
some degree to the style of a work.

If the word, style, refers to any factor establishing
a relationship among works, such a trait may be thought of
as a heading around which works can be grouped for study.
For some purposes, one recognizes a shared characteristic
in different works without regard for the question of time--
in order to study relationships as if in a timeless sphere.
However, an art historian's analysis usually concerns traits
in works as they persist during time. Since nothing occurs
during a span of time without transformation, such considera-
tion involves changing relationships. The composite situa-
tion of relatedness and development is cause for concern to
some scholars.

George Kubler says, "If we proceed on the assump-
tion that style is both relational and developmental, we need
to test the connection between relatedness and change."[2]

His examination leads him to conclude that "A major con-
tradiction arises from the use of the term style. The idea
of style is best adapted to static situations, in cross-cut or
synchronous section.... When we are dealing with large
durations, words describing time work better than exten-
sional words like style."[3] Acknowledging the wisdom of
this observation, in this volume the word, style, is defined
as the simple relatedness of traits; the word, sequence, is
used here as in Kubler's The Shape of Time for the com-
posite situation of relationships in the flow of time. How-
ever, until the word, sequence, is generally adopted, the
term, style, is often called on to perform double duty. A
thoughtful reader may decide that, even occasionally in these
pages, what is called a "style" really refers to the develop-
ment of a "sequence."

By whatever labels, related traits in art works within
the context of the flow of happening are a proper concern of
the art historian. He deals with the fact that the creation
of an art work occurs in time, and artistic relationships
are bound up with matters of duration. Basic questions
about art in its historical context confront the art historian.
Must there be shared traits among art works in a given
historical situation? If so, why? If relatedness at a given
moment or in a given place is likely, must developments
during time affect a body of works in a similar way? Again,
why? Such questions may never be satisfactorily answered.
Partial responses proposed by authorities who try to find
answers may contain helpful insights.

The first question concerns why a group of works
done under related circumstances, by the same artist or by
artists close to one another in date or geography, tends to
betray a telltale homogeneity. For one answer, it seems
undeniable that art is self-generating. Heinrich Wölfflin
spoke, over a half century ago, of a "concept of representa-
tion" that pervades the tradition in which an artist is im-
mersed. To Wölfflin, this concept of what art should look
like affects the artist to a degree that is "much more im-
portant than anything he takes from direct observation."[4]
More recently, E.H. Gombrich is emphatic in stating that
art is born of art, not nature. "Even after the development
of naturalistic art, the vocabulary of representation shows
a tenacity, a resistance to change, as if only a picture seen
could account for a picture painted. The stability of styles
in art is sufficiently striking to demand some such hypoth-
esis of self-reinforcement."[5] Specific cases of a geograph-
ically based stability of styles having remarkable endurance

will engage our attention in the chapter on predilection in art.

The second issue concerns why a style tends to be transformed in a homogenous way. Gombrich has studied this problem especially as it applies to realistic art--should the representation of the illusion of appearances have a history? If a perfect likeness is the goal, why does realistic art endlessly ebb and flow? Gombrich finds the conquest of reality is far from simple because there is no single objective standard of accuracy in fidelity to nature. The issue is bound up with the psychology of perception; one sees what a cultural orientation leads one to expect to see. Because a society changes in its goals, parallel developments, shifts, and reversals occur with various artists in that society. The culture's attitudes are built into the aspiration to imitate nature. The same question may be asked about non-realistic art--must abstraction have a history? Again, varying goals and the absence of an invariable standard of success account for a certain amount of instability, and culturally induced changes result in limited possibilities for the artist. Examples of changes in styles along common lines will be the topic of the final chapter on invention.

Consciously or not, the artist feels impulses to conform and impulses to be different, impulses to repeat the past (his own and that of others) and impulses for change. Full justice would not be done to the resulting work if it were to be regarded in isolation. The study of relationships among art works encourages awareness and appreciation of both shared and unshared qualities. The merits of the unique work are brought into focus by the study of style and sequence.

Chapter II

FORM

Form in art concerns the matters of line, shape, and
surface texture and color. The fifteenth-century architect
and theorist, Alberti, used other terminology for these three
components of form. He speaks of circumspection, composi-
tion, and reception of light.[1] Alberti defined circumspection
as outline; he explained composition as the organization of
shapes in relation to one another; and he identified reception
of light as the way colored surfaces appear to vary accord-
ing to the illumination. This chapter is concerned with these
same components of form, but the terminology is tailored to
present needs. An art work in which line is emphasized will
be said to have linear-and-planar form; when shape is em-
phasized, the term will be linear-and-plastic; when the sur-
face is especially important, painterly form.

This choice of terminology modifies the scheme de-
veloped in the early twentieth century by Heinrich Wölfflin.
In his Principles of Art History, Wölfflin contrasts linear
art (alternate labels he gives are "draughtsmanly," "plastic,"
"tactile" art) with painterly art.[2] He goes on to develop
four additional sets of contrasting terms: plane versus re-
cession; closed versus open form; multiplicity versus unity;
clearness versus unclearness. For this volume's purposes,
the first polarity serves as fundamental; the remaining ones,
admittedly somewhat redundant, are subsumed as aspects of
the basic distinction between the linear-and-plastic and the
painterly.

Importantly, Wölfflin's primary alternate (linear versus
painterly) is here expanded from an "either-or" choice into
a three-way option (linear-and-planar, linear-and-plastic,
painterly), and the Wölfflinian concepts have been reinter-
preted as the enlarged scheme suggests. One significant
advantage of the addition of a third category is that the frame
of reference becomes more widely applicable than before.
Wölfflin limited his discussion to a comparison of the

sixteenth and the seventeenth centuries; his followers applied
Wölfflin's polarities to some other situations; now the scheme
is relevant to even more periods of art history.

As a preliminary caution before fully defining the
terms, it must be stressed that Wölfflin's alternates, as
here reinterpreted, are nothing more than degrees marked
on a measuring scale that contains infinite gradations. In
fact, the poles simply become convenient tags for the recog-
nition of relative emphasis; his "painterly" becomes a syn-
onym for "the less linear."[3] In this way, Wölfflin's lan-
guage becomes useful for purposes that are much less ab-
solute and arbitrary than critics of the system have acknowl-
edged to be possible. What is of value has been salvaged--
a vocabulary for the study of form, or a language for
"morphology." The vocabulary is employed in this volume
to distinguish art works according to the relative importance
of those ingredients common to all works of art--line, shape,
surface texture and color. For instance, whereas most
every work of art employs line, only those works in which
line is particularly stressed deserve to be called linear.
Over half a century after Wölfflin's book, when modern art
has invalidated some assumptions he took for granted and a
broader outlook on the world's art has weakened others, it
is still unquestionably helpful to one's perception of style to
link together art works that have a similar formal character.

In order to define each form category, three works of
art will be examined, in turn, that illustrate linear-and-
planar form, linear-and-plastic form, and painterly form.
A fairly isolated and typical example of each of these formal
types naturally occurs in different media. Black-and-white
drawing lends itself to linear-and-planar form; sculpture
lends itself to linear-and-plastic form; and oil painting is
particularly appropriate to painterly form. Later, examples
of art works will be studied in which qualities are empha-
sized that do not naturally arise from the character of the
medium.

a. The linear-and-planar

This outline drawing by Aubrey Beardsley (Fig. 1)
is achieved largely by means of lines. Taking nothing for
granted, just what is a line? It must be conceded that a
line is no more than a long, narrow shape. Next, are
there lines in nature? One strand of a spider's web might

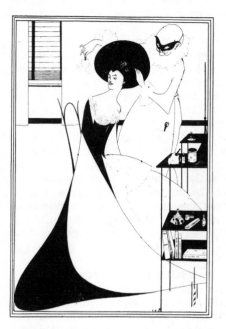

A prime example of
the linear-and-planar
occurs in line drawing.

Figure 1. Beardsley: <u>The Toilet of Salome</u>
Illustration to Oscar Wilde's <u>Salome</u>

qualify, but, if magnified, the slimmest thread loses its
linearity and becomes a broad band. If an artist were at-
tempting to draw the way a thread appears under a micro-
scope, he would resort to using lines to indicate the <u>bound-
aries</u> of the band. Thus, it becomes clear that a line <u>is a
draftsman's</u> convention for rendering the <u>edges</u> of a natural
shape. With slim objects, one line <u>suffices;</u> with broader
things, more than one line is required. Beardsley uses
lines to depict the edge of a table leg, the edge of a hand,
the edge of a skirt. With other items, such as the brimmed
hat, the original working lines are disguised by the fact the
artist filled-in the entire area of the bonnet with black; but
everyone is so accustomed to the idea of boundaries being
equated with lines, one "reads" the edge of the hat as a
line. Lines are simply a convenient pictorial notation, so
familiar to all of us that we rarely question their legitimacy.

When an artist relies heavily upon line, his work is given
the adjective, linear; or since a draftsman is one who draws
lines, Wölfflin suggests the synonym, draftsmanly.

The concept of the line has become so well rooted
that it is even customary to speak of lines which are only
implied rather than drawn. More properly, suggested lines
might be labeled axes; an axis is an imagined path. For ex-
ample, there is such a "line" implied by the direction of the
gaze of the two figures in the Beardsley; this line is roughly
parallel to the left-hand edge of the table top. Indeed, there
is a "line" all the way from the upper right corner to the
lower left described by the placement of the figures. This
long diagonal has a fluid, free quality to it, not only because
it varies as one reinterprets the work, but it is associated
with the swooping curves of the central figure. This imag-
ined diagonal line is offset by the actual, choppy horizontals
and verticals in the lower right and upper left. A combina-
tion of drawn and imagined lines gives the linear personality
to this work.

Notice also that the Beardsley drawing remains es-
sentially a flat pattern on the picture plane with very little
suggestion of recession. (The picture plane is the two-dimen-
sional surface of paper, canvas, etc., on which the artist
works. The picture plane is usually properly positioned in
regard to the scene represented upon it when it is placed
vertically upright.) In this example, lines transcribed on the
picture plane do not deny the flatness of that surface--they
do not try to convince you that it is something other than a
plane. Works of art having this characteristic are called
planar, a term coined to mean the quality of relative flat-
ness in art. As this example demonstrates, planar form is
entirely compatible with linear form. In this drawing, linear
form and planar form are so closely associated that it is ap-
propriate to assign a compound label, the linear-and-planar,
linking both formal qualities. (In subsequent usage, when the
full term is awkward and the meaning is clear, one may rely
simply on the word, linear, or on the word, planar.)

Usually, there is some illusion of depth in a relatively
linear-and-planar work. Often, standing figures seem to be
behind the picture plane rather than upon it, but, generally,
such figures seem to avoid poses in which there is dramatic
recession. Their arms and legs tend to remain confined, as
it were, within an imaginary plane that is parallel to the
picture plane, moving side-to-side and up-and-down more

than in-and-out. Why is this so? Because a fundamental
characteristic of boundary lines is that they tend to empha-
size the breadth of things rather than depth. One reads
across from one edge to the other. Without aid from an-
other quarter (namely, shading), mere outlines--either left
plain or filled-in with color--encourage planarity.

Sometimes lines are forced to do non-linear tasks
and the result is an exception to the rules above. This oc-
curs in the graphic arts. In engraving, for example, the
medium has only lines at its disposal, lines scratched on a
copper plate. To overcome this limitation, the engraver,
by a supreme effort, makes line suggest volume, color, tex-
ture, and light. Then his work parades as something other
than mere line, assumes something different from a linear-
and-planar character, and enters one of the form categories
to be considered later.

Strictly speaking, it should be possible to achieve
non-planar effects with mere line simply by convincing the
eye that the line recedes rather than travels across the
field of vision of the beholder. Such a possibility, rep-
resented by Figure 2, could be labeled linear-and reces-

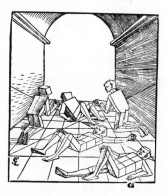

This is an example of
a line drawing that is
linear-and-recessional
(for contrast with Fig-
ure 1).

Figure 2. Erhard Schön: Schematic Bodies

sional. This exercise in foreshortening and perspective
is from a sixteenth-century book of drawings by Erhard
Schön. Testimony to the fact that such form is an unlikely
feat is the rarity of works that could be placed under
this heading. The Schön makes an effort to be strictly
linear and at the same time recessional. It makes an in-
teresting contrast to the Beardsley drawing (Fig. 1). The
work by Schön achieves the illusion of recession by placing
the figures in a manner that is distinctly not parallel to the
picture plane--they are foreshortened. The illusion of re-
cession is supported by placing the figures in an architectur-
al setting with receding walls--this is called a perspective
view.

 Foreshortening and perspective are terms that may
need further explanation. When an artist wants to give an
illusion of depth, he draws a scene from an angle in which
an object or objects are distinctly receding, rather than
stretched-out parallel to the picture plane. In such a case,
the objects are said to be foreshortened. The word, fore-
shortened, suggests that an object (such as a person's arm),
when projecting forward or backward, appears shortened;
it appears longer when it is stretched-out to the side. The
systematic codification of a method for drawing foreshortened
objects is called perspective. Perspective concerns what
might be designated the "railroad track phenomenon"--put
another way, parallel lines which recede from the picture
plane appear to converge on the horizon. Experimentally
arrived at by Brunelleschi, a fifteenth-century architect, it
was first expounded theoretically by Alberti,[4] whose ex-
planation was a preliminary step to the understanding of the
"railroad track" rule; and the subject was of immense in-
terest to fifteenth- and sixteenth-century artists, among them
Erhard Schön.

 Although line alone, via foreshortening and perspec-
tive, can provide the illusion of depth, the majority of re-
cessional drawings do not rely on line to do all of the work
of creating the illusion. Shading is the natural companion
to recession. Even Schön has not entirely resisted employ-
ing shading. He suggests (in Fig. 2) that the left-hand wall
catches the light, the right side is in shadow. Thus, linear-
and-recessional art does not constitute a major tradition in
art history; more often depth is achieved by what will be
defined as plastic means. Linear-and-plastic art can per-
haps be best introduced initially via sculpture....

b. The linear-and-plastic

 This piece of sculpture by Jean Arp (Fig. 3) illus-
trates plasticity. The word, plastic, means capable of being
molded. In art, it refers to the concern for three-dimen-
sional volume and implies particularly those qualities asso-
ciated with modeling in clay or carving in stone. Most
simply, plastic is the equivalent of sculptural. (Note: This
definition of the word, plastic, is different from a broader
sense of the word meaning any tangible form--as when the
visual arts are called the plastic arts.) Naturally, sculpture

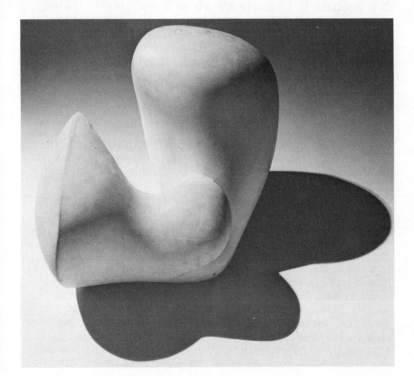

A prime example of
the linear-and-plastic
occurs in sculpture.

Figure 3. Jean Arp: Human Concretion (Collection, the
Museum of Modern Art, New York. Gift of the Advisory
Committee.)

provides striking examples of plastic--or sculptural--form,
and in this work by Arp the swelling volume is indeed of
primary importance. The bulging fullness of the form is
entirely unlike the thin crispness of the Beardsley. The
effect on the observer is quite different; one senses the
work's volume displacing space as one's own body is sensed.
Notice, however, the contour, or silhouette, also plays a
part in the comprehension of the statue. One sees the edge
as an outline because the familiar conventions of drawing
are carried over to the interpretation of sculpture. (For
that matter, when looking at any three-dimensional object,
it is habitual to translate the visual experience of the edge
of the shape into the mental shorthand of a line.) Here,
between the edges/lines, the form is plastic. As in the
case of the prior examples, it is appropriate to assign a
compound label linking two related formal qualities--this
work is linear-and-plastic. (As was suggested in the earlier
instance, when the context makes the meaning clear, such
compound terms may be shortened; the word, plastic, by
itself, often suffices.)

So far considered have been an example of linear-
and-planar form in the medium of drawing and an example
of linear-and-plastic form in the medium of sculpture.
These two types of form are "at home," so to speak, in
these media. However, types of form are not the exclusive
possession of a single medium, as will be presently dis-
covered.

Still to be seen is an example of the quality that
is natural to painting. Of course, the painter relies on
linear-and-planar form and on linear-and-plastic form to
some extent; however, when working with a brush, the
painter becomes particularly conscious of the surface on
which he works. He is aware of paint as paint, a medium
rich in the potentials for texture and color. Oil paint,
especially, encourages this attitude. This orientation natur-
ally leads to painterly form--just as drawing lends itself to
linear--or draftsmanly--form and sculpture lends itself to
plastic--or sculptural--form. Now, for the example....

c. The painterly

This oil painting by Turner (Fig. 4) emphasizes
surface; that is, texture patches and color masses. There
are almost no lines at all. There is very little sense of

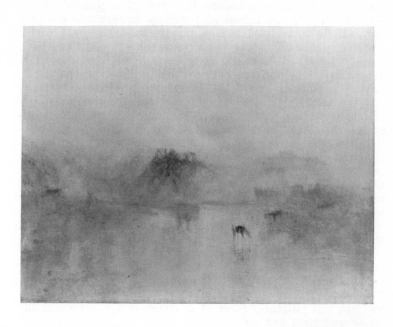

A prime example of
the painterly occurs
in oil painting.

Figure 4. Turner: <u>Norham Castle, Sunrise</u>

three-dimensional volume. Instead, there are areas of color
that fade into one another. Since outline is dissolved, the
paint itself holds our interest. Here, the surface has a liq-
uid character. Sometimes painterly surfaces are even more
thin and smooth; sometimes they are thick and rough. In
all painterly art, the area within the lines draws one's atten-
tion, and one's eye retreats from the outline, or edge of a
shape. Wölfflin explains that painterly vision concentrates
on the mass: "Seeing in masses takes place where the at-
tention withdraws from the edges, where the outline has be-
come more or less indifferent to the eye as a path of vision,
and the primary element of the impression is things seen in
patches. It is here indifferent whether such patches speak
as colour or only as lights and darks."[5]

In this book, the handling of light and the handling of
space (two additional elements that are often considered in-
dependently) will be linked with surface texture and color;
they will be associated with painterliness. The first, light,
obviously is basic to any visual experience. Light is neces-
sary to reveal all things--lines, shapes, and surfaces; it is
a consideration in all aspects of form. However, particular
lighting conditions reveal and heighten subtleties of surface
and are intriguing to the painter who concentrates on special
effects of texture and color. Thus, the painterly artist be-
comes interested in providing an illusion of "particular
light." (The painter who is not especially interested in tex-
ture and color is likely to give general illumination to his
painted scene.) The second matter, space, may be only an
empty shape in a given work, such as the cubic space of a
room interior. Then space involves plastic form. However,
when a space has a special atmospheric condition, as a room
filled with smoke, that volume ceases to be simply an empty
shape; it has texture and color. A painter depicting such a
room employs the same formal means appropriate for sur-
face texture and color. He works in a painterly way. The
painterliness of the Turner invokes a sense of "particular
light" and of "atmospheric space." It is a fine example of
the fact that painterly form is appropriate for rendering the
illusion of light and space.

d. Transference

It has been seen that linear-and-planar form is na-
tural to drawing, that linear-and-plastic form is natural to
sculpture, and that painterly form is natural to oil painting.
But each of these various media may borrow formal qualities
associated with another. Observing this phenomenon of
transference is the next step.

First, however, it must be explained that although
drawing and painting have been contrasted for the purposes
of form theory, they have so much in common they are usu-
ally considered together. Drawing is, for most practical
purposes, a kind of painting. The theoretical distinction,
having served its purpose, can be disregarded from now on.
Henceforward, what is said of painting can be assumed to
apply also to drawing, unless special note is made.

The three fields that deserve attention from now on
will be the so-called major arts: painting (including

drawing); sculpture; and architecture. The last of these three, architecture, has not been mentioned before, so it is appropriate to pause and ask what form is "natural" to architecture (using the word employed in the preceding discussion of other media). The natural form for architecture is actually enclosed space. As Bruno Zevi has pointed out in Architecture as Space, the monuments of all of the major periods of architectural history may be interpreted in terms of the articulation of spaces.6 However, the enclosure, rather than the space enclosed, often attracts one's attention; and theoretically speaking, the enclosure must always borrow formal characteristics from one of the media already discussed.

Now, applying theory to practice, first to be considered is the case of painting appearing not painterly, as already seen, but relatively planar; then, painting appearing relatively plastic. A similar procedure will be followed for sculpture and for architecture.

Painting exhibiting linear-and-planar form: although inherently painterly, paint may be handled in a manner that is predominately linear-and-planar, as in an eleventh-century manuscript page of St. Benedict and St. Desiderius (Fig. 5). Here the edge of a shape is a distinct line, and the space between edges is filled-in uniformly suggesting a child's coloring book. An artist of this persuasion takes an outline drawing to a state of seeming completion before he finally adds color. In a theoretical sense, this eleventh-century manuscript illumination is a colored drawing rather than a painting.

Painting exhibiting linear-and-plastic form: a painter may give his work the illusion of plasticity. Although he may begin with an outline drawing, he may employ a technique quite different from the previous example. He may shade from light to dark within the outline, thus giving a sense of volume to what had heretofore appeared flat. This linear-and-plastic technique is exemplified by Masaccio's fresco of the Tribute Money (Fig. 6). The shading here gives the illusion of projection and recession. The artist has decided on a light source from the right-hand side and has shaded the areas of drapery and other objects that would not naturally catch the light. By this means, forms emerge as if they were sculptured. This is called modeling in light-and-shade, or chiaroscuro--literally "clear-obscure" in Italian. Whereas the word, chiaroscuro, is used by some

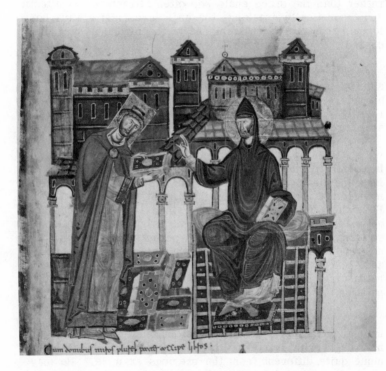

Figure 5. St. Benedict and St. Desiderius

Examples in painting of the linear-and-planar, the linear-
and-plastic, and the painterly. (Note the contrasts between
the depictions of buildings.)

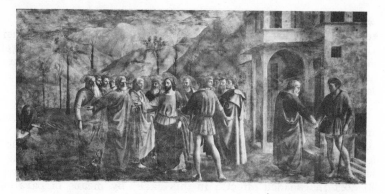

Figure 6. Masaccio: The Tribute Money

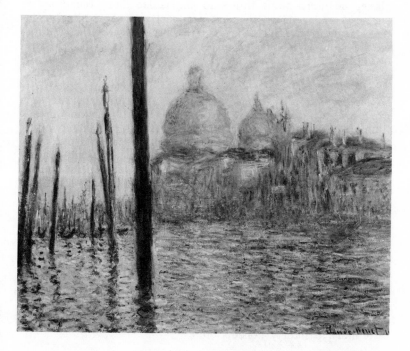

Figure 7. Monet: The Grand Canal, Venice

writers to describe works that are predominately dark in
tone, in this text the word implies effects achieved by transi-
tions of light to dark. (Care must also be taken to interpret
correctly the meaning of the word, light, in context. Light-
and-shade, chiaroscuro, is a vehicle for plasticity; "particu-
lar light" is associated with painterliness.)

Drawing, a sub-heading under the category of painting,
may easily suggest plasticity through shading. With pencil
or charcoal, the technique is most natural; with pen and ink,
a drawing may suggest plasticity through crosshatching. As
has already been mentioned, the line drawing by Schön (Fig.
2) contains shaded effects; in this case, by means of parallel
lines.

A natural companion to shading in painting (and draw-
ing) for the illusion of depth is the distribution of objects
in a recessional manner. Rather than placing objects near
at hand, the painter suggests that some things are in the
distance. Rather than placing objects parallel to the picture
plane, he turns some things to emphasize their receding
surfaces and renders them in perspective. Accordingly, in
the Masaccio painting (Fig. 6), the recession of the building
on the right-hand side enhances the sense of depth achieved
by the shading of the figures.

It must be added that virtually all paintings require
some suggestion of forms in space. The painterly Turner
work already discussed (Fig. 4) is not totally lacking in the
illusion of three-dimensional shape. Another painterly work,
a Venetian scene by Monet (Fig. 7), makes use of perspec-
tive to a certain extent and even models in light-and-shade
to a degree. There is a difference, however, in the role of
color in many painterly works as compared with color's role
in relatively plastic ones, such as the Masaccio Tribute
Money. For Monet, light-and-shade is a matter of color
contrasts--pinks and oranges for the lighted side of a build-
ing and greens and lavenders for the shaded side. Chiaro-
scuro in Masaccio is a matter of tonality--light blue for the
illuminated side of Christ's robe and dark blue for the
shaded side. Monet's method relies on color; Masaccio's
method mixes-in varying amounts of white or black to lighten
or darken the color. White and black tend to reduce the in-
tensity of pigments; pure color contributes to the high key
of a more painterly conception. [7]

To recapitulate, both the Turner and the Monet are

relatively painterly. On the other hand, the Medieval manu-
script has demonstrated that painting can be relatively planar,
and the Masaccio has demonstrated that painting can be rela-
tively plastic. Clearly, all three basic types of form--
linear-and-planar form, linear-and-plastic form, and painter-
ly form--are represented in this one medium. As for draw-
ing and the graphic arts, which will be slighted in the in-
terest of brevity, these media may in certain cases appear
not linear-and-planar, as their "liney" vocabulary might sug-
gest, but shaded (as in the Schön) or painterly through tone
areas that give effects of light and color patches (as in
Rembrandt). Now to proceed, finding sculpture exhibiting
similar flexibility.

In sculpture, the inherent plasticity of the material
is linked with the concept of a tactile appeal, that is, with
the desire to touch something. For example, one feels
little inclination to touch an ordinary road map but one is
inclined to run one's fingers along a relief map of paper
maché. This natural impulse is the one which occurs when
one observes a statue--although museum guards frustrate
this impulse. An example of sculpture clearly demonstrat-
ing the tactile appeal of the medium is a work by Brancusi
(Fig. 9). The title of the work is pertinent: Sculpture for
the Blind. With such a starkly simple, plastic shape, the
sense of touch without visual confirmation would be sufficient
for one to grasp the nature of the work.

At this point, a fine distinction must be made. As
the term, tactile, will be used in this text, it implies that
the sense of touch is called upon to assess projection and
recession. Closely related but slightly different is the tex-
tural interest of an uneven surface of paint. As this latter
has to do with surface rather than with shape, it will be
designated as a textural appeal rather than a tactile one.

Now, having observed two works of sculpture that
are distinctly plastic--the Arp work (Fig. 3), through which
the term plasticity was initially introduced, and the Brancusi
(Fig. 9), in which the importance of a tactile appeal in plas-
tic sculpture was noticed, it is time to demonstrate that
sculpture may also be linear-and-planar or painterly.

Sculpture exhibiting linear-and-planar form: when
sculpture employs lines on what is essentially a plane, such
as in this Egyptian case of "sunk relief" (Fig. 8), it mas-
querades as draftsmanship. In this work, the design was

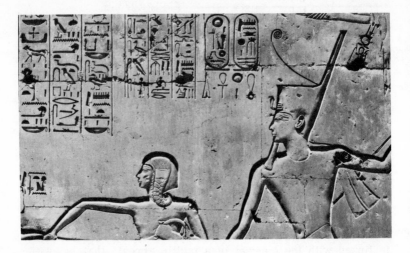

Figure 8. Rameses II and his Son

Figure 9. Brancusi: Sculpture for the Blind

Examples in sculpture
of the linear-and-
planar, the linear-and-
plastic, and the painterly

Figure 10. Rodin: Man With the Broken Nose

cut into the surface of stone with a sharp chisel. The in-
strument was handled like a pencil to draw lines. Another
sort of sculpture that is dramatically linear-and-planar is
low relief (or bas relief) in which the ground surrounding
objects is cut away, revealing a clear front plane against
a background surface.

Sculpture exhibiting painterly form: perhaps at first
it seems difficult to imagine sculpture treated in a painter-
ly manner. In the case of Rodin, painterliness is essen-
tially textural, resulting from the exaggerated manipulation
of the uneven surface (Fig. 10). It was noted earlier that
sculpture in general makes a tactile appeal but the "tor-
tured" surface of this piece creates a visual excitement be-
yond the usual tactile interest. Other sculptors deal with
matters normally associated with painting by concerning
themselves with light. Obviously, any light must be pro-
vided by actual, external sources rather than by internal
illusion, contrary to the case of painting in which light may
be rendered in a scene by the artist. A sculptor can con-
trol the play of light upon his work by placing it in relation
to external light sources. Also, through deep undercutting
a sculptor can accentuate cast shadows. These means in-
troduce the painterly quality that is sometimes called "color"
in sculptured works.

Thus, sculpture, like painting, may emphasize a
formal characteristic different from its inherent one.

Architecture is the remaining category of the major
arts. In many ways, architecture is a composite medium.
For one thing, architecture quite literally employs painting
and sculpture as accessories in the ornamentation of build-
ings. Perhaps it is to be expected that architecture also
figuratively borrows from drawing, sculpture, and painting;
that is, architecture may be estimated in terms of relative-
ly linear-and-planar form, relatively linear-and-plastic
form, and relatively painterly form.

One may observe architecture exhibiting the three
basic types of form in a comparison of three Italian Renais-
sance façades (Figs. 11, 12, 13). The fifteenth-century
building, Sant' Andrea at Mantua by Alberti, is clearly
planar when contrasted with the plasticity of the sixteenth-
century design for St. Peter's by Bramante. Sant' Andrea
has flat pilasters applied to the flat surface, whereas St.
Peter's does not have a single wall plane but appears as a

combination of volumetric blocks, bulging outward and
stacked upon one another. Sant' Andrea is conceived as a
pattern on a plane; St. Peter's, as a form in space. Dif-
ferent still is the seventeenth-century San Carlo alle Quat-
tro Fontane by Borromini (Fig. 13). Here, the undulating
surface gives a sense of texture that is generally asso-
ciated with painting.

e. Sequence

 Having looked at the planar, plastic, and painterly
first in their native soil and then transplanted into the
alien terrain of other media, it is time to ask whether
there is any predictability in the appearance of the various
types of form or whether they pop up unexpectedly in any
fertile field. In answer to this question, a survey of art
history establishes that, at any given period of time, one
of these characteristic types of form tends to dominate all
three major arts. This suggests not only that there is an
interrelationship among the media but, further, that these
types of form are not mere chance occurrences. It would
appear to suggest that each type is especially appropriate
to certain circumstances.

 To test the idea that a certain type of form is
compatible with a certain environment and differs from
that of another, two Medieval cathedrals, Chartres and
Amiens, one started in the mid-twelfth century and the oth-
er in the thirteenth century, serve as examples. Clearly
the two churches share many of the characteristics of the
Gothic cathedral. They have the twin-towered silhouette
and three portal entrance in common, round rose windows
and repeated pointed arches. Nevertheless, there are dif-
ferences. The stonework of the west face of Chartres is
distinctly planar, and the windows serve to penetrate that
definite plane of the wall surface (Fig. 14). Also, Chartres
is known for the superb stained glass of its windows which
contain bold, two-dimensional patterns. Stained glass, be-
ing bits of colored glass suspended between lead strips, is
a kind of "painting" that lends itself to linear-and-planar
designs. Both the wall treatment and window treatment at
Chartres indicate that linear-and-planar form is appropriate
to the spirit of the twelfth century in France. As the
Gothic progressed in the thirteenth century, as exemplified
by the Amiens façade, the distinctness of the plane is lost
because of a much more plastic wall treatment (Fig. 15).

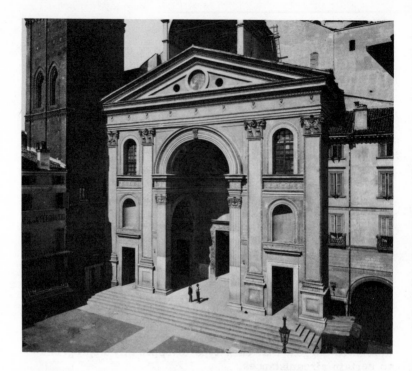

Figure 11. Alberti: Sant' Andrea, Mantua

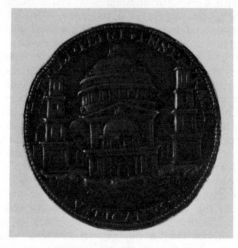

Figure 12. Bramante: original design for St. Peter's, Rome (medal by Caradosso)

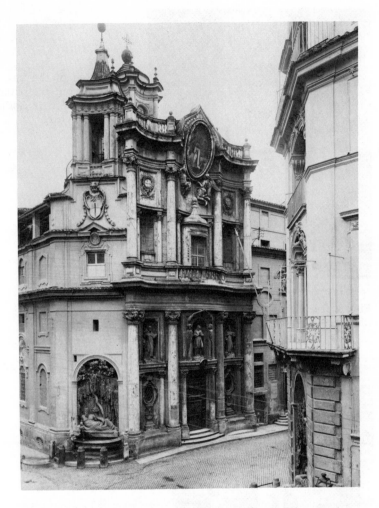

Figure 13. Borromini: San Carlo alle Quattro Fontane,
Rome

Examples in architecture of the linear-and-planar,
the linear-and-plastic, and the painterly

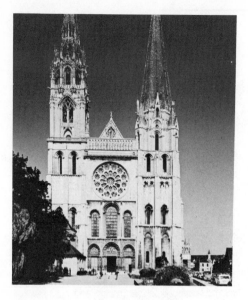

Examples of the sequence from the planar to the plastic in Gothic architecture

Figure 14. West façade
Chartres Cathedral

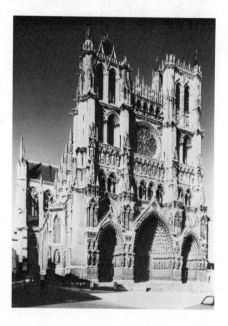

Figure 15. West fa-
çade Amiens Cathedral

Similarly, the stained glass of Amiens depicts objects in a more three-dimensional manner.

Partisans of the stained glass of Chartres have maintained that the quality of the glass at Chartres could not be equalled when, in later cathedrals such as Amiens, the taste of the culture developed toward greater plasticity. A value judgment should not intrude with the simple recognition that later artists suggested more depth in stained glass scenes rather than embracing the linear-and-planar character often expected of the medium. To demonstrate the danger of preconceived criteria of quality, the sculpture on the portals of these buildings reinforces the point. Predictably, the twelfth-century jamb figures of the west entrance to Chartres are relatively linear-and-planar; they are less fully rounded than those of the thirteenth-century west façade of Amiens. In the case of sculpture, people might maintain that the medium requires plasticity and might prefer the figures of Amiens; yet the glory of the Chartres sculpture is universally acclaimed. Either a relatively planar monument or a relatively plastic one may contain supreme examples of different sorts of walls, windows, and sculpture.

A developmental pattern is beginning to emerge. Notice, in the case of the two Medieval cathedrals just discussed, the earlier façade is relatively planar and the later façade is relatively plastic. Also, in the case of the three Italian Renaissance churches (Figs. 11, 12, 13), the earliest is planar, the middle one is plastic, and the latest is painterly. Other examples demonstrate a similar progression. One may conclude that, often, when a tradition develops without interruption or outside stimuli (such as a culture-shattering war or the influx of foreign ideas), it tends to move from a tenuous linearity, to a firm plasticity, and to resolve in time into the painterly synthesis of light and color. The reasons for this sequence are complex and not fully understood; the pattern is not inevitable, not even desirable. Merely, it sometimes occurs.

As an example of the sequence, Greek sculpture provides a clear demonstration (Figs. 16, 17, 18). The sixth century B.C. "Hera" of Samos seems an inviolable trunk on which sensitive slender lines are drawn, the lines contrasting with the sturdy mass. The fifth century B.C. Lemnian Athena evidences more full, weighty folds of drapery, these having a tactile appeal. The second century B.C. Winged Victory of Samothrace is the most complex of the three; it

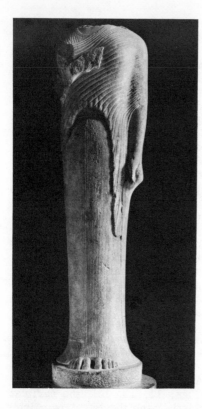

Figure 16. "Hera" of
Samos

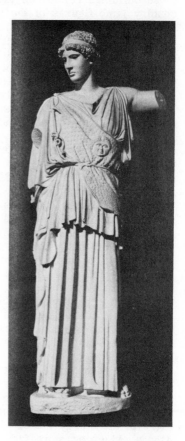

Figure 17. Athena
Lemnia

Figure 18. <u>Nike of Samothrace</u>

Sequential development in Greek sculpture of the planar,
the plastic, and the painterly

suggests not only the stuff of the fabric but the body beneath.
Because of the complexity of the surface, with its visual and
textural interest, this work may be labeled painterly.

This development is more than a progression toward
greater naturalism, it is more than the increase of the
artist's skill, although in Greece both illusionism and tech-
nical facility happen to develop also with the passage of
time. To show that form development may be considered
in addition to questions of likeness and virtuosity, one might
consider sculptured heads from the same centuries (Frontis-
piece). The crisp delineation of the features of an Archaic
Kouros evolves into the broadly modeled forms of the head
of the Doryphorus and eventually into the rippling texture of
the flesh of the Laocoön. Each head achieves a measure of
literal description and each handling has its own technical
refinement, but the differences between the works have to
do with more than imitation of nature, more indeed than
sophistication. One recognizes an increase in naturalism
and skill; yet each work has its own particular formal vo-
cabulary and its own virtues.

One concludes that both the "Hera" of Samos and the
captivating, lively Kouros are mature statements of profes-
sional artists and are completely accomplished within their
linear vocabulary. No defense is necessary in the case of
the Lemnian Athena and Doryphorus, as this sculptural
treatment has struck a responsive chord in almost every
generation since the "Golden Age" of Greece. The Nike of
Samothrace and the Laocoön may seem a bit exaggerated to-
day, as if the artists were self-consciously displaying their
skill by imposing a painterly texture upon unyielding stone,
yet on their own terms they are the equal of the others.

Italian painting provides another demonstration of the
development from draftsmanly form, to sculptural form,
and finally to painterly form. The early Italian school may-
be represented by an altarpiece by Margaritone of Arezzo
(Fig. 19). There is something map-like about the tracing
of characteristic outlines upon a plane. The artist never
forgot that the picture plane was, indeed, a plane. Upon
the surface, lines are transcribed. The human figures are
entirely at home within the ornamental borders because the
whole scheme is conceived as a flat pattern. Interestingly,
it is claimed by the sixteenth-century biographer, Vasari,
that Margaritone was aware that a new, more plastic man-
ner was supplanting his style. [8] Vasari commented that

Margaritone, humanly enough, regretted the waning of his
linear-and-planar form and the coming of a new age. We,
in our day, might wonder why Margaritone did not recognize
that the human figure is a volume in space. This would be
forgetting, however, that Margaritone's flat patterns are
symbols for heavenly beings, not human beings. The figures
are simply identified by being depicted in tableaux related to
their human existence. Who can insist that plastic form is
most appropriate to symbolize heavenly beings?

The new style that Margaritone saw coming is pio-
neered by Giotto. Giotto conceived of the picture plane as
a window through which one sees a view of the real world.
He revived the almost forgotten technique of chiaroscuro as
a means to achieve convincing volume for human figures.
A century later, this plastic style was pursued by Masaccio,
and as the fifteenth century progressed, it gained an increas-
ing number of adherents. In Domenico Veneziano's handling
of the subject of the Madonna and Child with Saints (Fig. 20)
--the same theme as the Margaritone painting, the heavenly
figures are no longer indicated by separate tableaux but are
represented standing together in a human existence. And
they inhabit a specific earthly space--thanks to the resources
of Brunelleschi's perspective.

The early sixteenth century in Rome and in Florence
saw the culmination of the linear-and-plastic style with such
people as Michelangelo. Significantly, Michelangelo was
primarily a sculptor, and he protested about being forced to
paint the Sistine Chapel ceiling. No wonder that, in the
case of the Sistine ceiling, the painted figures are so very
sculptural that it seems the frustrated sculptor was painting
the titanic statues of his imagination (see Fig. 6).

After the stunning virtuosity of this plastic style came
the development of a more painterly mode. The transition
in taste encouraged progressive artistic leadership to shift
to Venice, where light and color had traditionally been empha-
sized. Tintoretto is a good example of the extreme reached
by Venetian painterliness (Fig. 21). Tintoretto envisions the
Madonna and Christ in Paradise surrounded by a multitude
of angels, saints, and the faithful in a heavenly radiance in
which the figures "coalesce with clouds of light to form vast
concentric swirls. Light, color, space merge in a tremen-
dous cosmic drama to which individual figures as actors are
subordinated."9

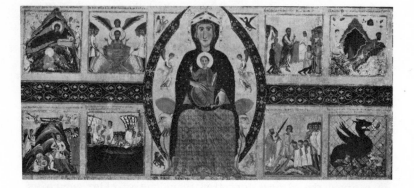

Figure 19. Margaritone da Arezzo: Madonna and Child with
Scenes of the Lives of the Saints

Figure 20. Domenico Veneziano: Madonna and Child with
Saints

In Italian painting,
there is a development
from the planar, to the
plastic, to the painter-
ly

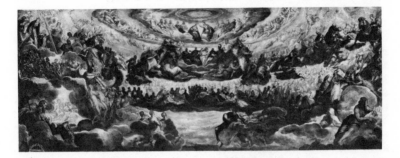

Figure 21. Tintoretto: Oil sketch of <u>Paradise</u>

f. Exceptions to sequence

Instances of the sequential development from linear-
and-planar form to linear-and-plastic form to painterly form
have been illustrated by shifts in the styles of certain West-
ern art history periods. Obviously, within these same peri-
ods, there occurred exceptions and reversals which contra-
dict the observed trend. Significantly, at other periods and
locations, no even-paced development in types of form is
demonstrable or relevant. In certain situations, some in-
dividual artists seem to accelerate the whole development
in their own lifetimes. A few examples of these and other
exceptions deserve attention.

A reverence for tradition may stabilize forms into
conventions. In such instances, a society may indefinitely
retain a certain type of form. For example, both Egyptian
and Byzantine art prolonged a relatively linear-and-planar
stage. Both cultures promoted a highly religious art. Be-
cause of the religious significance of the art and the nature
of each religion, any excessive deviation in form offended
the sense of permanence and immutable rightness. In Egypt,
originally for clarity's sake and eventually for tradition's
sake, it was proper to show each part of the human body
from its flattest, most stretched-out point of view; the head
in profile, the torso frontal, the legs profile (see Fig. 8).
In Byzantium, the folds of drapery became a pattern of lines

radiating from a knee or an elbow. (This was the tradition
from which Margaritone's style was derived, Fig. 19.) In
both cases, these conventions were repeated for generations,
even centuries, without much apparent change.

On the other hand, an artist like Titian can be said
to reflect, in his own development, a progression from a
relatively linear style, to a more plastic one, and finally to
a painterly old-age style. When this sequence is considered
in terms of the development of an individual's facility, it
seems natural indeed. The student may draw careful out-
lines and avoid foreshortening because they are difficult for
him; the young adult may be fascinated with the potentials of
shading and perspective; and the mature artist, with assur-
ance gained from a lifetime, picks up his brush and, without
need of preliminary sketches, spontaneously dashes-in shapes,
colors, textures, with a few strokes. Of course, this order-
ly development is hypothetical and rarely clearly observable
in an actual case. Too many other factors enter the picture
--the artist's teachers, the current style, etc. But, in
some cases, this progression provides a helpful hint in
guessing whether a work is a student product or the product
of a seasoned artist.

The subject of the development of the individual artists
in relation to the sequence of types of form proves helpful
in certain cases. For example, true "folk" artists in the
Western world tend to work in a somewhat linear-and-planar
manner. They are not at ease with chiaroscuro and per-
spective. Until they have overcome these obstacles, they
are limited to this type of form. However, the limitation
does not necessarily mean that folk art is inferior to work
by trained professionals. It merely means that such work
must be judged within a linear-and-planar frame of reference.
Folk art may be meaningfully compared with linear-and-
planar work done by professional artists in order to evaluate
its quality.

For reasons which are not entirely clear, art from
1400 to 1900 does not lend itself to the planar-plastic-painter-
ly sequence. During that interval, major European periods
conspicuously neglected linear-and-planar form. For five
centuries, the major shift appeared to be, instead, an alter-
nation between the plastic and the painterly; a brief review
of European painting during these centuries will establish the
battle lines in what became a war of styles.

It has already been mentioned that the plastic form
of Masaccio (Fig. 6), Veneziano (Fig. 20), and of Michel-
angelo gave way to a more painterly style as represented by
Tintoretto (Fig. 21). Pushing painterliness even further than
Tintoretto, seventeenth-century artists in the north, such as
Rembrandt and a number of lesser Dutch artists, became
particularly absorbed with light and atmosphere. In time,
there was a reaction against painterly form on the part of
academic artists. The French Academy of Art, founded in
the mid-seventeenth century, fostered a return to the linear-
and-plastic style. This manner of working--stressing draw-
ing and shading above brushwork and color--was officially
approved by the French government in the late seventeenth
century and on into the eighteenth century. With the author-
ity of government behind plastic art, for a time it may have
appeared that the pendulum would stop swinging.

The government found it hard to suppress the latest
painterly style, called Rococo art. It was necessary for the
official position to soften because of the undeniable attrac-
tions of the radiant, sensuous Rococo. With difficulty, the
French Academy and the Royal Academy in England (modeled
after the French) maintained the posture of supporting an
emphasis on drawing and shading rather than painting. The
academies preached allegiance to the draftmanship of the
Florentine and Roman Renaissance and warned against the
"inferior" Venetians who "debauch the young and inexperi-
enced" with dazzling color.[10] In France, it was largely be-
cause of Jacques Louis David, a formidable champion of
academicism at the end of the eighteenth century and in the
early nineteenth century, that it was some time before
painterliness could gain clear ascendancy. He delayed for
a generation the faltering of academic leadership that would
eventually enable painterliness to prevail. Finally, the early
nineteenth-century painterly style, called romantic art, was
strong enough to confront and openly challenge the old guard.

The confrontation of the rivals--the conservative,
academic tradition of linear-and-plastic art and the bold,
new painterly style--may be represented by the works of
Ingres and Delacroix. A simple comparison of two portraits
from the eighteen-thirties will concentrate attention upon
form--the linear-and-plastic technique versus the painterly
one (Figs. 22 and 23). From here on, the influence of the
academic position upon young artists diminished.

The most important exception to a planar-plastic-
painterly progression concerns our own time. Any methodical

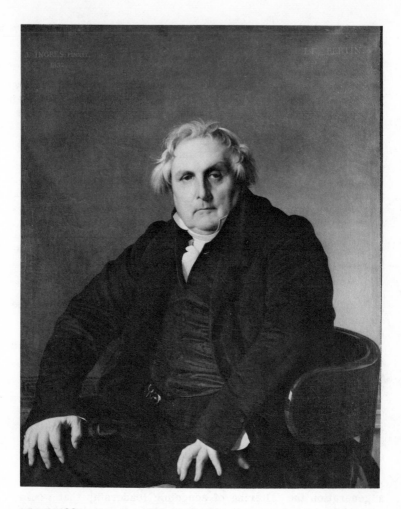

Figure 22. Ingres: <u>Louis Bertin</u>

A case of the confrontation of the
academically-sponsored plastic style
and the academically-disapproved painterly one.

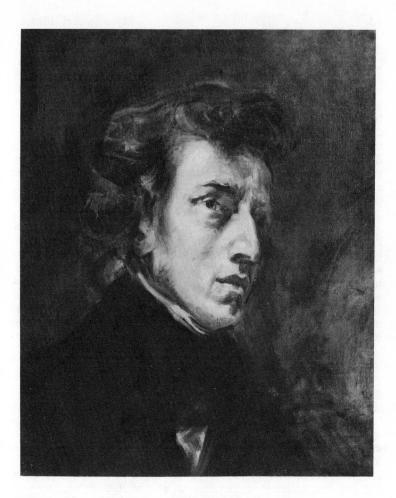

Figure 23. Delacroix: <u>Fréderic Chopin</u>

development from one stage of form to another has complete-
ly exploded in the twentieth century. Among the reasons:
artists are no longer dependent upon a few teachers and local
ideas. By walking through a metropolitan museum or simply
by flipping the pages of a book, an artist may traverse the
length and breadth of art history. The ease of modern
transportation and communication--and especially the advent
of photography--have changed irrevocably the predictable
flow of form development that often existed in the past. The
very diversity of form in the art of today is testimony to the
confusing, conflicting stimuli acting upon the artist in un-
predictable combinations.

Clearly, the planar-plastic-painterly sequence is less
relevant for our own time than it was in the past, and it
may not be a major factor in the mainstream of Western
art for the future. Nevertheless, the sequence may prove
helpful in the study of art styles of the past. It is not nec-
essary to discard a form theory that is applicable mainly to
the past when the problem at hand is an historical one. The
situation of contemporary art becomes, when seen with some
objectivity, merely one instance among many in which there
is exception to an often observed trend.

g. Different interpretations

Many art historians have reservations about any clas-
sification of art works by form categories such as the pre-
ceding planar, plastic and painterly ones, more concern
about the observation of sequence patterns. They fear it
may be forgotten that groupings of works are simply devices
for the convenience of the student who wishes to organize
the unwieldy sum of individual works. Indeed, unless warned,
a person might lose sight of the fact that categories of any
sort are imposed on the works from without and are not an
inherent part of the art objects. It must be emphasized that
the effort to group art works into a limited number of cate-
gories is inaccurate at best and, if abused, worse than no
organization at all. As Gombrich complains, it could be
like trying to classify all men as either tailors or cobblers,
all women as cooks or parlormaids. [11]

Another criticism frequently made is that simple dif-
ferences in form will be confused with estimates of quality.
James Ackerman laments, "a value concept lurks in the
shadows"; [12] and Gombrich is suspicious that forms will be

confused with norms.[13] Certainly, it must be stressed that
form categories are entirely independent of evaluations of
quality. Not only the clear-cut examples of form types but
those less definable in-betweens are potentially supreme
works. Somewhat related is the most horrifying spectre to
the art historian--fatalism. Not very long ago, art histo-
rians shuddered to think that what is often observed might
be considered to be inevitable, that frequent patterns of
change would be translated into iron-clad determinism. To-
day, this danger has lessened somewhat because recent art
has been characterized by the unpredictable, and modern ex-
perience on all fronts has demonstrated that nothing is cer-
tain. Yet, a shadow of the old monster--fatalism--still sur-
vives. Ackerman fears that likely patterns of change will
be interpreted as desirable and works will be judged accord-
ing to whether they are "destiny-fulfilling" or "destiny-deny-
ing."[14] Our legacy from the nineteenth century--a concept
from Herbert Spencer of progress being linked with change--
makes for a still-present danger here. It must be insisted,
development in a predictable way does not mean improve-
ment; change in a surprising fashion does not result in either
lower or higher quality.

 Counterbalancing these dangers is the hope that some
system, even an imperfect one, when used with caution, is
better than no system at all. Whereas no schema can serve
beyond a certain limited usefulness, some service can be
exacted from classifications of form.

 To test the planar-plastic-painterly designations
against some alternative attempts to provide a system for
grouping works by form, it is appropriate to go back to the
end of the nineteenth century and retrace the steps taken by
scholars of style theory. Victorian literature on art had
been characteristically poetic rather than scientific; the writer
often was frankly subjective in his assessments of works,
and his language frequently attempted to evoke in words the
spirit of the artist's creation.

 In his early books of the eighteen-nineties, Bernard
Berenson was still Victorian in his self-assured, personal
estimations of the quality of an artist, and he frequently dis-
missed as inferior those men whose works were motivated
by goals different from his expectations. However, anticipat-
ing the shift toward a more objective sort of writing, he
tried to tie his analysis to general aspects of form. As he
summarized his own theory in 1907:

All the arts are compounded of ideated sensations,
no matter through what medium conveyed, provided
they are communicated in such wise as to produce
a direct effect of life-enhancement. The question
then is what, in a given art, produces life-enhance-
ment; and the answer for each art will be as dif-
ferent as its medium, and the kind of ideated sen-
sations that constitute its material. In figure
painting, the type of all painting, I have endeavored
to set forth that the principal if not sole sources
of life-enhancement are TACTILE VALUES, MOVE-
MENT, and SPACE COMPOSITION, by which I
mean ideated sensations of contact, of texture, of
weight, of support, of energy, and of union with
one's surroundings. Let any of these sources fail,
and by that much the art is diminished. [15]

Also writing at the turn of the century is Alois Riegl;
he became the forerunner of all twentieth-century theorists
who try to detach themselves from value judgments by ex-
plaining that works should be judged by the artist's standards
rather than by the criteria imposed by the critic. In addi-
tion, Riegl made an interpretation of Western periods which,
in timing, is quite different from the pace of the planar-
plastic-painterly shifts proposed here. Riegl saw one grand,
slow sweep from ancient art to his own day in terms of the
development from the "haptic" to the "optic." [16] By the
haptic, he meant art in which forms result from what one
feels when empathizing with the object depicted. Generally,
the more tangible and tactile works, such as sculpture, are
haptic. Taking a broad view of the ancient period, he rec-
ognized that sculpture, and sculptural considerations in ar-
chitecture and painting, predominated. In his view, it was
not until late antiquity that optic--that is, visual--concerns
of particular light and atmospheric space became important.
Late Roman arts and crafts were the special focus of Riegl's
volume; to him this art was an advance toward the long-
range goal of the optic. This goal was subsequently pursued
by the Germanic tribesmen; Medieval monks and burghers;
Renaissance and Baroque artists; and finally the Impres-
sionists.

Riegl's sweeping view is discredited today as being
totally inflexible and simplistic. If any system is nothing
more than a tool, shifts that can be reckoned by the genera-
tion and the century are clearly more useful than the vastly
larger patterns of millennia. Riegl's theory is too amorphous

and unwieldy to warrant the generalizations and inaccuracies
it requires. The criticism is softened by reluctant admira-
tion for what Gombrich calls the "touch of genius in the
singlemindedness with which Riegl tries by one unitary prin-
ciple to account for all stylistic change."[17] Also, to Riegl's
credit, through his book the concepts of the more tactile
versus the more visual enter into the general domain.

 Writing only a bit later, in 1915, Wölfflin was familiar
with Riegl's idea of a polarity, and he developed one of his
own. Lacking our knowledge of mid-twentieth-century art
and scholarship, factors that have led us to grant to non-
Western, primitive, and Medieval art greater attention than
did he, Wölfflin valued, above all, Greco-Roman antiquity
and the Renaissance-through-nineteenth century. His Prin-
ciples of Art History was concerned with the latter period
during time the linear-and-plastic alternated with the
painterly. The limited chronological focus accounts for
Wölfflin's bi-polar scheme. Indeed, Wölfflin even narrowed
his attention within the span of European art of recent cen-
turies; he concentrated on the early sixteenth century, that
period called the High Renaissance, and selected instances
of the seventeenth century, the so-called Baroque. The
shortcoming in Wölfflin's book, to modern eyes, is not so
much the system as the prejudices that intrude into the ap-
plication of the ideas. He excludes from consideration art
that is unrelated to either of his two form categories; also,
he dismisses works that fall somewhere between the two
form categories and works that exhibit mixed characteristics.
For example, Wölfflin ignores entirely the art of the late
sixteenth century, the style called Mannerism.

 Wölfflin's scheme is inadequate for us today when,
among other things, we are especially sympathetic with
what has been called here linear-and-planar art--both the
planar art of recent times and that of remote cultures. It
is hard to forgive him for saying, "The preliminary stages
of the High Renaissance are not to be ignored, but they
represent an archaic form of art, an art of primitives for
whom established pictorial form does not yet exist."[18] Also,
it is contrary to current thought to rank well-defined ex-
amples of a form category as qualitively superior to less
clear-cut instances; yet Wölfflin is emphatic about the fact
that he finds only two summits in artistic achievement--the
High Renaissance and the Baroque seventeenth century. "The
occidental development of modern times--has two culminating
points. We can turn our sympathy to one or to the other."[19]

Today, art historians do not operate with the assumption that works can be measured against constant norms; rather the artist's election of one way of working means that he foregoes other desirable possibilities. As Gombrich explains it, current thinking operates under a principle of sacrifice rather than a principle of exclusion. [20]

In the decades following Riegl's and Wölfflin's books, the idea of polarities caught on as a way of diagraming the possibilities available to the artist despite the charge of being simplistic; however, Erwin Panofsky was influential in leading a shift away from polarities of _form_ to those of _meaning_, or what he called "iconology." Examples of meaning polarities: Paul Frankl wrote in terms of Being versus Becoming, each with three stages--preclassic, classic, postclassic; Curt Sachs spoke of ethos versus pathos; Lincoln Rothschild used the labels, analytical versus sensational. [21] These terms are couched in the language of content, not form. Sir Herbert Read also emphasized meaning not only the matter of content but the artist's intention. "Frankly, I do not know how we can judge form except by the same instinct that creates it." [22] Further on, he says the artist's sensibility "stands more chance of being liberated in the spectator if he had prior understanding of the artist's intention." [23] In short, as the twentieth century progressed, form took second place after considerations of intent and content, which is to say, meaning.

An alternate trend in the second quarter of the twentieth century was the rejection of considerations of style altogether, in favor of documentation of borrowings. Art historians were fascinated by the force of tradition and by the fact that even the most "original" periods are in debt to their predecessors. As late as 1960, Gombrich asserts, "Investigations of these continuities have now largely replaced the older preoccupation with style"; but he goes on to say, "The time seems ripe to approach the problem of style once more, fortified by this knowledge of the force of traditions." [24]

At mid-century, a return to an interest in style, and to matters of form, in particular, is perceptible. Meyer Schapiro helps refocus attention on form by stressing that form has replaced subject matter in modern non-representational art as the vehicle for conveying expressive content. The new liberty introduced by abstraction has, "as one of its consequences, a greater range in the appreciation and

experience of forms."[25] Schapiro analyses recent non-
illusion in formal terms, particularly in regard to the topic
of order. He says of the modern artist, "He is attracted
to those possibilities of form which include a considerable
randomness, variability and disorder, whether he finds them
in the world or while improvising with his brush, or looking
at spots and marks, or in playing freely with shapes--invert-
ing, adjusting, cutting, varying, reshaping, regrouping, so
as to maximize the appearance of randomness. His goal is
often an order which retains a decided quality of randomness
as far as this is compatible with an ultimate unity of the
whole."[26]

 Gombrich also is interested in the topic of order in
relation to realistic and abstract art. To him, order can
be opposed to naturalism:

> Clearly, the more a painting or a statue mirrors
> natural appearances, the fewer principles of order
> and symmetry will it automatically exhibit. Con-
> versely, the more ordered a configuration, the less
> will it be likely to reproduce nature. It seems to
> me important to stress at this point that, in my
> view, both order and fidelity to nature are reason-
> ably objective descriptive terms. Wölfflin was
> right to think that one can say, within limits at
> least, which work exhibits more of these charac-
> teristics than another. The kaleidoscope presents
> an orderly arrangement of elements, most snap-
> shots do not. An increase in naturalism means a
> decrease in order. It is clear, I think, that most
> artistic value rests among other things on the exact
> reconciliation of these conflicting demands.[27]

Obviously, Gombrich is not entirely in accord with Schapiro.
To Schapiro, non-representation is an opportunity for dis-
order; for Gombrich, the absence of naturalism is an occa-
sion for order. Basically, what unites the two theorists is
the return to the concern for composition.

 With Gombrich's alternates, "order and naturalism,"
there is a bridging of levels of consideration. Order versus
disorder would be poles expressed in terms of form; the
unnatural versus naturalism would be a polarity expressed in
terms of subject matter. In this instance and elsewhere,
Gombrich cuts across two zones; to me, Gombrich repre-
sents that freedom to break down boundaries claimed by

modern scholars. After the early twentieth century's in-
creasing specialization and ever narrowing concentrations of
intellectual endeavor on all fronts, this is refreshing. In
art, morphology (the study of form), iconography (the track-
ing down of symbols and narrative allusions), iconology (the
analysis of meaning), and areas of period specialization (such
as Medieval art, Renaissance art) need cross-fertilization.
Since the 1950s, Gombrich has led the way in an interdisci-
plinary effort to relate art history and the psychology of per-
ception. One major trend since mid-century is certainly the
recognition that valid intuitions need not abide by the bound-
aries between scholarly disciplines.

In 1962, George Kubler wrote a significant volume
treating form with a theoretical view, The Shape of Time.
In the preamble, he makes clear that his purpose is "to
draw attention to some of the morphological problems of
duration in series and sequence. These problems arise in-
dependently of meaning and image. They are problems that
have gone unworked for more than forty years, since the
time when students turned away from 'mere formalism' to
the historical reconstruction of symbolic complexes."[28] To
Kubler, a work of art is a solution of a problem:

> Every important work of art can be regarded both
> as an historical event and as a hard-won solution to
> some problem... other solutions to this same prob-
> lem will most likely be invented to follow the one
> now in view. As the solutions accumulate, the
> problem alters.... The problem disclosed by any se-
> quence of artifacts may be regarded as its mental
> form, and the linked solution as its class of being.
> The entity composed by the problem and its solu-
> tion constitutes a form-class. [29]

Kubler feels that it is appropriate to distinguish be-
tween early and later moments in the linked solution to an
artistic problem, yet he wishes to avoid the unfortunate as-
sociations surrounding words like "primitive" and "decadent";
so he labels stages in a form-class "promorphic" and "neo-
morphic." His description of typical early and late stages
rings especially true:

> Early solutions (promorphic) are technically simple,
> energetically inexpensive, expressively clear. Late
> solutions (neomorphic) are costly, difficult, intri-
> cate, recondite, and animated. Early solutions are

integral in relation to the problem they resolve.
Late ones are partial in being addressed more to
the details of function or expression than to the
totality of the same problem. [30]

The impetus provided by Schapiro, Gombrich, and
Kubler has resulted in other discussions based on form.
Rather than the constant search for borrowings in scholarly
articles and books, formal assessments are reappearing.
For example, in a recent article (arising from a 1927 essay
written by D. H. Lawrence), Richardson and Ades discuss
the art of Cezanne in terms of tactile values, thus suggesting
the language of Berenson and Riegl. [31] A new book by Thomas
Munro, Form and Style in the Arts, an encyclopedic morphol-
ogical study, attempts to define existing terminology and de-
scribe individual phenomena rather than to propose new in-
terpretations. Almost lost within the catalogue of terms and
definitions is Munro's own contribution to form theory--alter-
nation of simplicity versus complexity. Since these qualities
are applicable to all artistic endeavors (his book covers lit-
erature, music, theatre, dance, and the visual arts), they
are appropriate for his purposes. Munro sees recent art as
a disturbing case of extreme simplicity through the reduction
of stylistic traits:

> One can hardly tell the story of European visual
> art in the late nineteenth and twentieth centuries
> without mentioning the numerous features, admired
> in previous generations, which were gradually
> omitted.... The aim of such works, it is said, is
> to stimulate the viewer's imagination rather than
> to offer him a finished work.... In describing recent
> trends in various arts, historians and critics often
> begin by telling of what has been left out, as if
> that were a positive trait instead of a negative
> one. [32]

Characteristic of all of these theorists, from Berenson
in the 1890's to Munro in 1970, is the drive to develop some
system for classifying works of art. Each writer finds cer-
tain labels useful as headings under which to gather works
of art into groups. Among the pioneers who sought classifi-
cations of form, Berenson looked for tactile values, move-
ment, and space composition; Riegl thought in terms of haptic
and optic qualities; and Wölfflin had five polarities, the first
of which was the linear versus the painterly. As time passed,
the fashion in scholarship became a concern for meaning

rather than form, but still the compulsion to provide clas-
sifications for organizing works persisted. Recently, some
of the scholars who have returned to formal criteria include
Gombrich, who opposes fidelity to nature with order, and
Kubler, who finds promorphs and neomorphs.

With all of this wealth of offerings to draw from, in
the foregoing pages in which I proposed the linear-and-
planar, the linear-and-plastic, and the painterly, I have
chosen to combine especially some of the language of Wölfflin,
which has a tried and proven day-to-day usefulness, with the
idea of sequences and the marvelous spirit of detached im-
partiality of Kubler. Appreciating that the approach through
form is not the only one, attention will next be turned to
Worringer, Gombrich, and others; and style will be con-
sidered through subject matter and meaning. In the process,
it will be seen that form, subject, and meaning are related.
The form and subject chosen by the artist represent, as
will be discovered presently, a commitment to a certain type
of meaning.

Chapter III

SUBJECT

This chapter is devoted to a broad view of the theory of subject matter and presents ideas about illusion versus non-illusion, or realism versus abstraction. A basic early twentieth-century source for any such discussion is Wilhelm Worringer's Abstraction and Empathy.[1] An important recent study concerned with one side of the subject matter duality, the illusion of reality in art, is E. H. Gombrich's Art and Illusion.[2] The approach of these volumes and the present chapter is a general one and differs from the study of the particulars of subject matter, or iconography, which is concerned with the symbolic meaning of items in specific works. Since each historical period has its own repertoire of favorite themes, iconography tends to be very much tied to period studies and requires a different lens from that which focuses on theories of abstraction versus realism. There is no standard name for the study of the presence or absence of illusion; as far as I know, one has not been proposed. Perhaps image-ol´ogy could serve.

Subject matter based on the appearance of objects in nature is most common in Western painting and sculpture. Such recognizable subjects are sometimes called images. Even subject matter based on visible reality but outside actual experience qualifies as imagery. For example, the image of an angel is usually that of a youth dressed in a white robe with wings attached to his shoulders. Although founded on natural objects, an angel is presumably not part of the visual experience of the average artist.

Certain artists feel such a great commitment to factual accuracy that they believe the repertoire of legitimate images cannot embrace unseen subjects. This attitude is one characteristic of styles named realism or naturalism. (Naturalism is sometimes distinguished as an intense version of realism but for present purposes the two can be considered synonymous. Similarly, illusionism serves as another rough

equivalent in this discussion.) Courbet, the self-appointed
spokesman for the style called realism in the mid-nineteenth
century, said, "Show me an angel and I will paint one." Of
course, the definition of realism changes with the definition
of reality. Caravaggio, the great realist of the beginning
of the seventeenth century, painted angels.

Even when an artist is conforming to contemporary
standards of naturalism, he is translating reality into another
material--perhaps stone, if he is a sculptor; a two-dimen-
sional surface, if he is a painter. Other fundamental char-
acteristics of the medium also limit what an artist can
achieve. For example, the realistic painter must try to
simulate the appearance of light with paint.[3] Right from the
outset, the artist is thwarted in his attempts to imitate na-
ture. Nevertheless, the compulsion to strive for what may
be termed verisimilitude, visual realism, or illusionism,
has been a powerful force over the centuries.

In spite of the impossibility of total success, of ever
fooling the observer for very long into mistaking an art work
for a natural scene, the artist finds his public remarkably
willing to play along with the game. This fortunate coopera-
tion on the part of the beholder makes the effort worthwhile.
As Gombrich has shown, the beholder brings to his examina-
tion of an art work a certain "mental set," or expectation
of what the work contains--what subject is rendered and how
it can be translated into stone or paint. With proper clues
and the absence of contrary signals, the beholder accepts the
illusion.[4]

Less common in Western painting and sculpture are
subjects frankly divorced from nature. For present purposes,
the absence of verisimilitude--of any degree or variety--may
be termed non-realism, abstraction, or non-illusion. In the
past, abstraction had been, most often, the result of pro-
gressive abbreviation of a familiar subject. In the twentieth
century, other possibilities opened up. For one, working
from fantasies and visions, a painter today may distort and
dislocate aspects of the visible world for emotion, wit, or
shock value. For another possibility, working from his
imagination, a painter may suspend the law of gravity, may
abandon normal spatial considerations, and may free pattern
and color to obey rules of composition and technique--satis-
fying artistic rather than natural laws. But, try as he will,
the abstract painter has a hard time creating an object that
has no relation to anything from visual experience. The

artist is trapped by his being human and by the human limit-
ations of the imagination of his audience. Curving lines be-
gin to take on the unintended semblance of animals and plants
in spite of him. Straight lines make reference to snowflakes
or skyscrapers. Total abstraction eludes him. The beholder
persists in seeing images even where they are not intended.
The artist has to struggle for non-illusion.

 Neither total reality nor pure abstraction is attainable.
A realistic image suggests a real object--but after all, a
painted image is an artifice, not reality. An abstract motif
is liberated from objective reality--but a painting cannot
step outside the human base of experience. Realism and
abstraction are like impossibly distant magnetic poles exert-
ing pulls on us. Since both are frames of mind, not attain-
ments, the fairly narrow range of actual subject matter
might more accurately be called an inclination toward at-
tempting to render the illusion of appearances and an inclina-
tion away from illusion. Artists tend toward one pole or the
other while not traveling very far from the equator.

a. The essence image

 At this theoretical equator is the seeming starting
point from which art sequences develop--the essence image.
Both realistic and abstract styles can usually be traced back
to this origin. A child's first effort at drawing; the tribes-
man's formula; the sophisticated Western artist's simple
line drawing done as if from memory: all exhibit character-
istics of "essentialism." In other words, the beginning of
art in any century and culture tends to look like the elemen-
tal stage of art in any other time and place. To demonstrate
the universality of child art, shown here is a drawing by an
Austrian boy that Emmanuel Loewy reproduced in 1900 for a
book that set forth a theory applicable to Greek art; the
drawing could be the work of an American nursery school
child of the 1970s (Fig. 24). As for the art of primitive
peoples, Loewy selected drawings by natives of British New
Guinea (Fig. 25) which look strikingly fresh and "modern."
To add to these illustrations, one might include the etched
lines by the painter Manet depicting the profile of the nine-
teenth-century French poet, Baudelaire (Fig. 26).

 The artistic essence, as intended here, is a simple
schema that serves as a substitute for something in nature
while frankly admitting that it is not a close imitation of

A child's first efforts; the tribesman's formula; the simple line drawing of a trained Western artist: all exhibit characteristics of the essence image.

Figure 26. Manet: Portrait of Baudelaire (etching)

Figure 25. Drawings by natives of New Guinea (from Loewy)

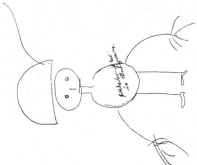

Figure 24. A child's drawing (from Ioewy)

appearances. Essences have been traditionally referred to
as "mental images" or "memory pictures." This frame of
reference is indebted to Loewy, who explained, "As a result
of the visual impressions which we have received from nu-
merous examples of the same object, there remains fixed in
our minds a memory-picture, which is no other than the
Platonic Idea of the object, namely a typical picture, clear
of everything individual or accidental. The graphic expres-
sion of this would be a scheme of lines and planes approach-
ing as nearly as possible simple geometric form.... Every
primitive artist, when endeavouring to imitate nature seeks
with the spontaneity of a psychical function to reproduce
merely these mental images."[5]

Loewy's assumption was that the artistic essence re-
sulted when an artist had the initial impulse to record some-
thing but did not test his work against visual evidence--he
worked from memory. Loewy himself felt obliged to caution,
"Perfect reflections, indeed, of these psychic processes we
may not hope to find even in the earliest archaic drawings
that have come down to us. Even in children's drawings we
hardly find them quite unmixed, and this irrespective of the
fact the child has not complete mastery of his pencil. For
the mere translation of the mental image into graphic form
contains a revolutionary germ."[6]

Today, a different reservation jeopardizes Loewy's
underlying assumption. Recent psychological research has
raised serious doubts as to whether people's mental images
are in fact simple schemata. Chances are, one's actual
mental images are fleeting glimpses of things that bear little
relationship to "memory picture" art.[7] Perhaps, rather than
being taken from a storehouse of remembered images, the
"essential image" is summoned up for the occasion to comply
with certain requirements of artistic endeavor. One require-
ment of the untutored artist is simplicity. He is concerned
with what is essential, stripped of everything extraneous.
Also, as Gombrich explains, an essence image, being a sub-
stitute for something in nature, is felt to require the sharing
of an essential element of the function of the natural form:
"The 'first' hobby horse (to use eighteenth-century language)
was probably no image at all. Just a stick which qualified
as a horse because one could ride on it."[8] The term, es-
sence image, has been adopted here both to get away from
the misleading connotations of the term, memory picture, and
to emphasize the need felt by beginning artists to be simple
and to suggest function.

Whatever word is selected, there is an undeniable connection between the way embryonic art appears and the freedom from visual relationships. The size of an object tells its importance rather than indicating either its scale in relation to other items or the distance of the object from the observer. In children's art, sometimes enormous heads grace little stick-figure bodies; staring eyes at the top of a head leave no room for forehead or hairline. In the art of early peoples, typical is the large size of gods and kings, the smaller scale of lesser men. Such conventions of arbitrary scale undoubtedly give rise to the idea that essentialism allows subjective interpretation to become interwoven with actual appearances as in remembered images.

Another typical characteristic in schematic art is the tendency to select a viewpoint that affords linear-and-planar form. To demonstrate this characteristic, imagine a fledgling artist about to draw a hand which he wants to be recognizable and unambiguous. He closes his eyes and visualizes a hand in several positions seeking clarity above all; he decides that the hand would be most clear if seen stretched-out so as to have all fingers visible, for the idea of five fingers is an inseparable part of one's idea of "hand." He proceeds to draw the hand, avoiding a foreshortened view which hides any essential characteristic. In other words, the outline is carefully drawn (the work is linear), and forms are positioned parallel to the picture plane (the work is planar).

Essence images are the instinctive approach for untutored artists, and from this starting point, a development away from such images in either direction is possible. For example, today's kindergarten child draws a green line at the bottom of a page for the grass and a blue line at the top of the page for the sky. He "knows" that the earth is below and the sky above. He does not record what can be readily seen, that the earth and sky meet at the horizon line. At this stage, the modern child is susceptible to the suggestion that his drawing can be improved either by going to the window and checking on the actual appearance of a real scene or by the opposite, by giving line and color freer rein. In other words, it is an easy step today for the artist of schematic images to become either more visual or more abstract. In earlier times, however, the development away from a schema in a single direction was often prescribed and closely guided by the culture. Only one path was open. The child had no real choice but was encouraged

to follow the route toward illusion or non-illusion adopted
by his elders.

Alternatively, essentialism can be refined and per-
fected rather than discarded. Occasionally in the past, a
culture found that essence images were the perfect compro-
mise that suited its purposes. Then this elemental manner
of working became an established tradition adhered to by the
most learned of men. For centuries, Egyptian art retained
a partly schematic style. The Egyptian artists demonstrated
by their selective application of some elements of descrip-
tive visual realism and some abstract conventions that this
was not an instinctive, untutored manner. The style was
straddling the fence, so to speak. Essence images in this
instance are a sophisticated middle ground rather than a
primitive style.

b. Illusion of appearances (visual realism, naturalism)

In Western painting and sculpture in recent centuries,
the goal of art usually was to render the illusion of appear-
ances. This was the situation from 1400 to 1900, during
which time the focus of those artists striving for realism
was not constant. Various technical problems have at dif-
ferent times preoccupied artists. One by one, problems
of representing the visible world have risen to the surface
and appeared to be of pressing urgency. A movement is
often called realistic when a problem of verisimilitude be-
comes a goal in itself.

In the fifteenth century, the problems of anatomy and
perspective became matters of almost passionate concern.
For example, Pollaiuolo chose the subject of the Martyrdom
of St. Sebastian (Fig. 24) partly because the saint gave him
the opportunity to demonstrate the ability to paint action
poses. Apparently each archer is shown twice in the altar-
piece, from one viewpoint and then from another. To dem-
onstrate his knowledge of spatial relations, Pollaiuolo made
a great effort to show that these figures surround St. Sebas-
tian. (Previous pictures showed flanking figures in the same
plane.) Furthermore, Pollaiuolo showed a deep landscape
vista in order to exercise his skill at perspective.

In the seventeenth century, the problems of represent-
ing specific light sources--such as candlelight, window light,
and even spiritual radiance--became universal concerns

An example of illusion (visual realism) emphasizing anatomy and perspective.

(National Gallery, London)

Figure 27. Pollaiuolo: The Martyrdom of St. Sebastian

binding together diverse artists. For example, Caravaggio did altarpieces for the Italian Catholic church; Velasquez worked for the Spanish court; and Georges de la Tour represented the French middle class (Fig. 25): all were concerned with light. They realized that the appearance of objects depends upon the intensity, the direction and the color of the light that reveals them.

In the nineteenth century, when many of the frontiers of visual realism had seemingly been conquered, the French Impressionists explored, among other things, the representation of the appearance of objects in bright sunlight. These artists (as exemplified by the Monet landscape, Fig. 7) were influenced by the infant science of optics. They recognized the prismatic rainbow of colors in apparently white light rays; they played with the intensity of vibrations set up by complementary colors. (Paradoxically, Impressionism may also be interpreted as a step away from realism. Since brush strokes began to have a life of their own independent

An example of illusion
(visual realism) em-
phasizing light.

Figure 28. Georges de la Tour: St. Joseph, the Carpenter

of the shape described, Impressionism, while a triumph of
illusionism, pivots toward non-illusionistic virtuosity. This
matter will be returned to later. 9)

Along with their other achievements, these artists
mentioned have in common the fact that they attempted to
increase the verisimilitude attainable in their day by con-
centrating upon problems: anatomy and perspective in the
fifteenth century; interior light in the seventeenth century;
outdoor light in the nineteenth century. Succeeding genera-
tions in each case could draw upon the knowledge made ac-
cessible through their efforts. Each problem was explored,
mastered, and then became part of the knowledge shared by
every artist.

With these explorations into realism, another path
can be traced in European art of recent centuries: from the
grandiose theme which goes under the label of "history paint-
ing"--religious and mythological narratives, to the incidental
theme--exemplified by "genre," still life, and landscape,
and finally, random glimpses of city streets and breakfast
nooks. Increasing casualness appears to be concomitant
with the protraction of realism, having been characteristic
of the evolution of the Greek period also (see page 67.)
It may be that when the extreme of non-lofty subjects is at-
tained, a shift in direction for art must occur simply be-
cause of the exhaustion of this avenue for development.

c. Non-illusion (relative abstraction)

There are some notable exceptions to the generaliza-
tion that Western art is inclined toward visual realism. One
expects freedom from the constraints of illusion in the minor
arts: rugs; glassware; furniture. Additionally, architecture
is not based on natural shapes but upon abstract ones. To
make a building look like a giant animal or plant would re-
sult in a disastrous monstrosity. Since it is immune to the
magnetic pull toward realism, architecture does not figure
in discussions of the swings toward one pole or the other.

A notable instance of art inclined away from the il-
lusion of appearances occurs in the remote beginnings of
Western civilization. Perhaps as early as 5000 B.C., in
the Neolithic period, a style of abstract pottery decoration
developed in the near east (Fig. 29). This type of abstrac-
tion was based on animal subject matter; here, a horned
ibex below; dogs and long-necked birds above. (As will be
considered shortly, the style represents a departure from
an even earlier illusionism in rendering animal subjects that
occurred in Paleolithic cave walls.) Neolithic abstract art
is so vital that it survives to affect a number of later tradi-
tions. It is fundamental to the formulas that became set in
pre-Dynastic Egypt and were never entirely outworn in later
Egyptian art. It affects Minoan art of the second millennium
B.C. and was a factor on mainland Greece as late as about
800 B.C.--with schematic human subject matter on Geometric
vases depicting funeral processions (Fig. 30). Also, it is
traceable to the widespread "animal style" conspicuous in
northern Bronze and Iron Age ornament, a style that sur-
vives into historic times (Fig. 31).

One obvious reason why these styles are abstract is
that their origins are bound up with craft traditions: basket
weaving; pottery; leather and metal work. Another more
philosophical reason was proposed in 1908 by Wilhelm Wor-
ringer and may still apply in part, even though, when set
forth, the state of scholarship concerning prehistory was
severely limited. Worringer desired to explain the occur-
rence of abstract motifs in early peoples. His theory of
"abstraction and empathy"[10] suggests certain possibilities
in regard to Neolithic, Bronze, and Iron Age abstraction
which require modifications today but, nevertheless, are
worthy of record. Indeed, his hypotheses provoke new ideas
and point up some essential differences between early ab-
stract art and non-realism of the present day. A brief

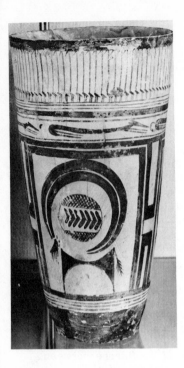

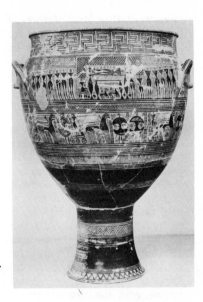

Figure 30. Dipylon
Vase

Figure 29. Painted beaker

Figure 31. Old Northern Bronze Clasps (from Worringer)

Examples of the inclination to non-
illusion (abstraction) in early times.

review of this line of thought, giving some background in the theory of Theodor Lipps and mentioning a major proponent, Sir Herbert Read, will be useful.

d. Abstraction and empathy

Worringer used as a foil a theory that had been for-mulated by Theodor Lipps at the close of the nineteenth century. Lipps was concerned with explaining the attitude that gave rise to the visual realism that occurs in the pre-ponderance of Western art, all that art ultimately based on Greece or the Italian Renaissance. He developed the notion of "Einfuhlung" which was adopted by Worringer; Einfuhlung was translated as empathy. As Lipps summarized it, em-pathy is "sensing myself through the direct impression of an object different from myself."[11] Sir Herbert Read in 1931 defined empathy as "feeling ourselves into art--when we contemplate a work of art, we project ourselves into the form of the work."[12] What is especially important about empathy is the psychological state which it symptomizes: Worringer said, "The precondition for the urge to empathy is a happy pantheistic relationship of confidence between man and the phenomena of the external world."[13]

Thinking especially of Neolithic painting and Germanic ornament from the Bronze and Iron Ages, Worringer de-veloped a counter-pole to the urge to empathy and labeled it the urge to abstraction. (Fig. 31 shows a plate from one of Worringer's books and exemplifies this principle.) Ab-straction, he said, "is the outcome of a great inner unrest inspired in man by the phenomena of the outside world.... We might describe this state as an immense spiritual dread of space."[14] Herbert Read concurred that in the art of primitive peoples there is "an expression of fear in the face of a mysterious and implacable world."[15] In a passage from a lecture originally delivered at Harvard in 1953, Read expanded on this notion:

> We know from survivals of such geometric types
> of art among aboriginal tribes today, that the emo-
> tion which inspires this non-representational tend-
> ency is fear--fear of the unknown, fear of events
> for which they have no causal explanation. We
> suppose, on the basis of analogous feelings of our
> own, that neolithic man was afflicted with a cosmic
> anxiety, a fear of existence or being. Fear

breeds secrecy, a desire to communicate in a
language that is not understood by the uninitiated
--by the hostile forces. Once we assume the need
for a secret language of this kind, then particular
motifs within the grammar of ornament might ac-
quire symbolic meaning.[16]

Worringer concluded, "The urge to abstraction stands
at the beginning of every art and in the case of certain
peoples at a high level of culture remains a dominant tend-
ency, whereas with the Greeks and other Occidental peoples,
for example, it slowly recedes, making way for the urge
to empathy."[17] However, Read did not agree that the ab-
straction of early man "stands at the beginning of every
art" and precedes the movement toward greater realism in
the Western world. Fresh information about Paleolithic art
led Read at mid-century to place more emphasis on the
naturalistic cave art that preceded abstraction:

It is possible that in the vast stretches of time
that intervene between paleolithic naturalism and
the naturalism that was to succeed neolithic ab-
straction, the geometric style had its separate
origin, as the expression of a specific psychic
state. That is Worringer's thesis, and the gen-
eral tendency of German thought on the subject....
But ... the general picture (is) of a naturalistic
phase of art preceding a geometrical phase. Much
as I hesitate to disagree with Worringer, my in-
tention is to show that in relation to the natural-
istic art of the Paleolithic period the geometric
art of the Neolithic period represents an extension
of aesthetic sensibility, and not, as he has sug-
gested, a contraction.[18]

The Neolithic art that both Worringer and Read were
concerned with is flat: one readily appreciates their argu-
ment--on the issue in which they are in agreement--that
flatness is appropriate to an era when a dread of the un-
known is equated with a dread of spatial depth. A corollary
is the fact that the two-dimensional surface in Neolithic ab-
straction is filled with patterning rather than containing un-
decorated emptiness. There was apparently a fear of any
void as well as the fear of depth. According to Worringer,
as civilization develops, the urge to abstraction--the fear
of spatial reality--becomes less strong and permits the urge
to imitate to be felt. When man begins to cope with his

environment, when he predicts and even controls it, he has
in a sense humanized it. He then is able to accept the
three-dimensional world in his art.

It is difficult for a Worringerian discussion of subject
matter to avoid entirely the Wölfflinian topic of form. The
Worringer theory, for example, argues that abstract art is
(in the terminology of the preceding chapter) planar, and
visually realistic art is plastic. The theory suggests one
reason for the phenomenon noted in the earlier chapter, the
sequence from planar art to plastic art. The reason: early
man retreats from the world with planar abstraction; later
man embraces the world in plastic realism. Clearly the
topics of form and subject are interrelated. This aspect
of Worringer's theory appears to knit very nicely with
Wölfflin's form theory. But, as in the case of Wölfflinian
thought, twentieth-century developments require the expan-
sion of Worringer's alternatives and the stripping away of
certain biases. Not only do recent discoveries about Paleo-
lithic realism unsettle Worringer's theory that the earliest
art was abstract, it seems that other reasons besides fear
may have inspired Neolithic abstraction. Indeed, modern
abstraction has shown that non-realism need not express an
urge to retreat from a hostile world.

Shortcomings in Worringer's primacy of Neolithic
abstraction can be related to his omission of the essence
image from his theory. Even Read's acknowledgment of
Paleolithic naturalism does not reach back far enough. Any
hypotheses about the beginnings of art should, to my way
of thinking, acknowledge the priority of the essence image;
from this common origin both abstraction and realism are
possible.

The essence image is the beginning of art, and it
continues to serve--as a connecting link--when style feels
an impulse to develop from illusion to non-illusion or vice
versa. Essences serve as a home base. Being planar,
like traditional abstraction, but not entirely out of contact
with the intention to record reality, the essence image
serves as a neutral zone where both abstraction and visual
realism claim roots.

With the concept of essentialism in mind, it is pos-
sible to modify both Worringer's theory and Read's revision
of it in regard to those historical periods where weaknesses
are revealed. These periods are at two extremes chrono-

logically, prehistory and modern times. For the purpose
of modifying traditional views, the current ideas of Gom-
brich prove useful. Accordingly, the terminology of Gom-
brich, "making" versus "matching," will be introduced and
expanded.

e. Making and matching, making and non-matching

 Gombrich's Art and Illusion concerns itself with the
development toward naturalism in art. He uses the terms,
making and matching, for what I have chosen to describe
as the development from the essence image toward the il-
lusion of appearances. Gombrich explains that making is
the "earlier and more awe-inspiring function of art when
the artist did not aim at making a 'likeness' but at rivaling
creation itself."[19] If Gombrich were now to write a volume
on art and non-illusion, perhaps he would label the path
traced, "making toward non-matching." This could be a
slogan for the development from making, whose goal is a
simple image that suggests the function of the natural ob-
ject, toward a willful distortion or exaggeration for expres-
sive reasons or for decorative purposes.

 At a colloquium at Wesleyan University in 1973,
Gombrich's topic was the motives for the presence or ab-
sence of naturalism. He explained that it is an oversimpli-
fication to assert merely that a development occurs from
one stage of representation to another. Even the most
primitive tribes can be shown to be capable of executing,
and of recognizing, lesser or greater naturalism. The is-
sue involves more than ability; the goals of each specific
work in the context of the society for which it was produced
determine its character. When a preponderance of works
from a given time and place exhibits a marked homogeneity,
there must have been a consensus in the society as to what
kind of art functions best.

 When seeking evidence about the presence or absence
of naturalism in the art of early peoples, special caution
must be exercised. Generalizations are risky because of
the incomplete information that has come down to us. All
art works made of perishable materials are lost; possibly
a dominant trend has vanished without a trace. Every new
archaeological discovery jeopardizes conclusions reached
before the find came to light. Despite these problems and
admitting that today's errors will be corrected when sub-
sequent discoveries are made, the fascinating journey back

in time imagined by Worringer lures again. One is tempted
to try to apply increased knowledge and test current ideas.

f. In search of early art

 The earliest art that Worringer focused upon was that
of the Neolithic, Bronze, and Iron Ages (roughly somewhat
before 6,000 to somewhat after 1,000 B.C.), so he assumed
that non-realistic art--non-matching art--was the springboard
for the development of the sequences of earliest civilization.
In some ways this view still holds; such abstract art did
precede Greek art in the Mediterranean world. However,
contemporary with Worringer, discoveries were being made
of an earlier art, that of Paleolithic man; and the newly-
found art of the cave man was astonishingly realistic. For
example, at Altamira, in Spain (discovered in 1879 and first
dismissed as forgery) and at Lascaux, France (found as re-
cently as 1941) there are bisons, horses, and other animals
rendered faithfully in proportion and posture. There is little
wonder that, for a time, the authenticity of cave art was
questioned. When accepted, the priority of this naturalistic--
matching--art (dating perhaps between 15,000 and 10,000
B.C.) disproved Worringer's theory. It showed that illusion
preceded abstraction in Western development. Worringer
may be right that a rejection of likeness in Neolithic times
was, in part at least, symptomatic of a retreat from un-
fathomable nature; but, as Read observed, abstraction can no
longer be described with certainty as standing at the beginning
of every art.

 Scholars now estimate that even naturalistic, matching,
cave art was preceded by thousands of years of lost, or as-
yet-undiscovered, images. What is the appearance of this
lost, earliest tradition? My hypothesis maintains that the
"essence image" must have been the salient characteristic of
this remote art. Gombrich's "the made" is the equivalent
for the essence image. Making represents an impulse for
creation; it precedes the ambition to imitate nature. Making
comes before matching: that is the catch-phrase Gombrich
employs to explain that the essence image officially inaugu-
rates art because it launches a cohesive body of works.

 Pushing back in our imaginations even further, how
did the first sporadic impulses to "rival creation" occur?
What preceded making? Gombrich guesses that the ultimate
source behind essence images shrouded in the obscurity of

ages was the irregular surface of a cave interior. He asks,
"Could it not be that the bulls and horses were first 'dis-
covered' by man in these mysterious haunts before they were
fixed and made visible to others by means of colored earth?"[20]
Gombrich thus proposes that the earliest art, really only a
prologue to a tradition, was "found"; as he puts it, finding
precedes making. Traces of art's primeval roots surprise
us when we find faces in a cracked plaster wall or animals
in a wood-grained door. So it was, says Gombrich, that
bumps and hollows gave birth to art.

This journey backward in time has gone as far as it
can; now to briefly review the sequence in chronological
order. First, in Paleolithic times, finding led to making:
with the eventual substitution of a made for a found object,
the real story of art begins. Next, making led to matching:
displaying incredible mastery, cave artists eventually learned
to render the powerful haunch of a guardian bison and dis-
tinguish the sagging mass of a fallen one, the swollen form
of a pregnant horse and the angular quickness of a deer.
But while cave artists perfected the difficult feats of illusion,
essence image simplicity was sometimes appropriate and
was used. Thus, a reversal of direction was possible. The
path might instead lead from essence to abstraction. Some-
how by Neolithic times, this alternate option was taken. In-
venting an additional phrase using Gombrich's frame of ref-
erence, one might say that making may proceed to non-match-
ing. This is where Worringer picks up the story.

g. Matching and non-matching in antiquity

Why did the shift to abstraction in Neolithic art occur?
To answer this question, Worringer's and Read's suppositions
may still have some validity. Fear may have been an under-
lying cause. Either a general fear of the unknown, as Wor-
ringer hypothesized, or the need for a secret language not
understood by hostile forces, as Read explained. Somewhat
differently, Gombrich supposes, non-realism may be the re-
sult of certain taboos concerning close imitation of nature.
It is an interesting thought that such fears and precautions,
rather than being evidence of man's animal-suspicions of the
unknown, may be connected with a growing sense of a reli-
gious restraint from "encroaching on the creator's preroga-
tives."[21] By the time of the Bronze and Iron Ages of the
third and second millennia B.C., another reason besides
fear may be involved. Examples such as the stylized symbol

for ankh (life force) in Egypt and the double ax (meaning
royalty-divinity) in Minoan Crete seem to have a magical
potency because of their veiled meaning. The minimal image-
sign seems suited to communication with the world of the
spirit. Another reason may have also played a part. Neo-
lithic abstraction is especially geometric and pared down to
essentials. Gombrich points out, "The geometric schema
requires something of a constructor's engineering skill, and
this skill and habit may have been developed with the needs
of settled communities--the rigid style of neolithic art coin-
cided with the development of agriculture and its technolo-
gy."[22]

 In time, non-matching would run its course and the
eastern Mediterranean could host a development in a different
direction. Egypt, with its obsession with the status quo and
the inhibiting reverence for authority, was an unlikely candi-
date for the next revolution. In the culture that succeeded
the Minoan in the Aegean region, Greece, the circumstances
became suited for change by the date of the Dipylon Vase,
around 800 B.C. Then, about contemporary with Homer,
the ferment began. Indeed, Gombrich thinks Homer's ad-
vances in poetic description may have demanded breakthroughs
in artistic description.[23] From this stage, Greek art was
shortly to develop toward greater naturalism. Since the
minimal image of the Geometric vase had not lost contact
with the essence from which it had been abstracted, the
process toward naturalism could be sought by returning to
the essence image and working in the opposite direction.

 On this topic also, Gombrich has revised the standard
assumptions. Whereas Emmanuel Loewy pioneered the analy-
sis of Greek art in terms of the shift from the conceptual
toward the perceptual and Worringer saw it as an urge to-
ward empathy, Gombrich is inclined to explain Greek art as
a kind of halting process of successive corrections of the
essence image, what he calls "schema and correction."[24]
This explanation should not diminish the awesome marvel of
Greek art. Even recognition of the fact that Paleolithic
man had instinctively worked toward illusionism thousands of
years before should not lessen the credit accorded to Greece.
The Greeks methodically and fully sustained their conviction
that art can be something different from the making of sub-
stitutes for things in nature. More completely than in pre-
history, the Greeks proved that art can be an illusion of the
way something appears to the artist; with Hellenistic art,
the image finally becomes no more than a representation

rather than a duplication. In Gombrich's words, "It was generally understood that an image need not exist in its own right, that it may refer to something outside itself, and therefore, be the record of a visual experience rather than the creation of a substitute."[25]

The steps this increasingly realistic art took may be traced formally from rigid linearity, to restrained plasticity, to engaging painterliness (see Figs. 16, 17, 18). In terms of meaning, as naturalism developed, Greek art may be described as taking a path from the remote and grandiloquent to the more casual. As to iconography, early vase painting preferred epic themes of gods and heroes; Hellenistic wall painting included landscapes and still lifes. This Greek development deserves to be called a revolution because it is so thorough and so prolonged that its effects have never been completely forgotten since.

After the flowering of Greece and Rome, involving roughly one thousand years, the time was ripe for a shift in direction. The opposite pattern, a rejection of illusion, occurs at the end of the Greco-Roman period. The multiple reasons and their effects are summarized by Gombrich:

> The conquest of appearances, sufficiently convincing
> to allow the imaginative reconstruction of a mytho-
> logical or historical event, was the end of classical
> art in more than one meaning of the word. The
> rise of the new religions from the East challenged
> this function. Perhaps that inevitable trivialization
> of the image which was the consequence of spread-
> ing skill and of joy of jugglery had made the art
> of mimesis vulnerable. In the time of Augustus
> there are already signs of a reversal of taste to-
> ward earlier modes of art and an admiration of the
> mysterious shapes of the Egyptian tradition.... What
> happened here (was) the adaption of the formulas
> to the new demands of imperial ceremony and divine
> revelation. In the course of this adaption, the
> achievements of Greek illusionism were gradually
> discarded.[26]

This breakdown of illusionism is quite different from a deterioration of art. Indeed, some things were recaptured that had been lost in the trade-off when making had been replaced by matching. Art had become casual and was no longer capable of seeming to embody universals; now "making" returned with all of its formality. One new demand of

art was to provide imperial authority. This demand is
satisfied with the Byzantine icon, which has an existence.
It is not a representation of something; it is something.
The Byzantine tradition epitomized this aspect of Medieval
art. It demonstrated anew that a hieratic function can be
served by essences, much as authority was served in pre-
Greek art. The second new demand of art was to indicate
divine revelation. This might be predicted to call for the
return of the image-sign. The fish and the initial letters
Chi Rho became Early Christian symbols for Christ in the
waning of the Roman Empire. These functioned much like
the double ax of the Minoans, partly because they were ab-
breviations whose meaning would not be obvious to the un-
initiated. Later, the Cross and the mandorla (an almond-
shaped halo) became Medieval image-signs. With these,
post-Greek art was reverting to the making of substitutes
for natural appearances; and the signs are not entirely un-
related to those shorthands of Egypt, Crete, and the Dipylon
vase (Fig. 30) which precede the Greco-Roman epoch.

h. Matching and non-matching in recent art

Does this discussion help one understand illusion and
the absence of illusion in modern art? Undoubtedly, there
have been striking changes in the subject matter of art in
the last two centuries. As Meyer Schapiro put it in 1937,
nineteenth-century criticism said, "How exactly like the ob-
ject, how beautiful!--the modern abstractionist says how
exactly like the object, how ugly!.... But as little as a
work is guaranteed esthetically by its resemblance to nature,
so little is it guaranteed by its abstraction or 'purity.' Na-
ture and abstract form are both materials for art, and the
choice of one or the other flows from historically changing
interests."[27] The problem is to try to understand the mo-
tives for the changing interests.

Worringer's theory serves only to a limited degree;
for modern abstract art, like the Neolithic and the Geomet-
ric Greek, cannot be explained as a simple rejection of the
three-dimensional world. To be sure, at the end of the
nineteenth century, there were elements of denial in Gauguin's
flattening of the spatial field, even before his retreat to the
island of Tahiti; there was a quality of escape in the effete
two-dimensional designs of Beardsley (Fig. 1). But modern
abstract art has become much more than escape; it suggests
a soul-searching reassessment and enlargement of the mean-
ing of "reality."

Gombrich's frame of reference proves more helpful. He sees the beginning of modern abstraction as occurring with Impressionism. "Impressionism stands on a watershed between two modes of satisfaction. It can be seen as the summit of the process that leads the pictorial symbol to be matched ever more closely with appearances, and as the beginning of an openly regressive art, of primitivism."[28] With this interpretation, Impressionism marks the start of modern non-realistic image making. Accordingly, parallels may be found between the recent breakdown of illusionism which begins with Impressionism and the start of non-realism in the earlier instances outlined--the Neolithic period and the close of the Greco-Roman period. Much as Gombrich described the early Medieval developments, the Impressionist and subsequent discarding of careful realism may have been partly the result of too great a facility which made slick representation vulnerable to the charge of vulgarity. Also, there is a certain amount of boredom and restlessness that seems to have infected both artists and their public in the late nineteenth century, and created a corresponding attraction to non-Western exotic traditions.

At the start, modern non-illusion, like that of the past, was characterized by a reductive process. The broad painting of Manet, the incomplete dashes of Monet (Fig. 7), and the staccato of the Neo-Impressionists all testify to an attitude that no longer seeks the most careful explicitness and fidelity to nature--the general effect was what mattered. While not as cryptic as the abbreviations for animals on a Neolithic pot or the image-sign of a fish on an Early Christian catacomb, there is a distant relationship. As in the former instances, the Impressionists chose time-tested themes with which the public would be familiar (in Monet's case, landscape); no problem of basic recognition occurs because the subject fulfills the expectation of the audience. To gently coerce the public into acceptance of the shortcuts, or at least to make the works fundamentally intelligible to the public, predictable subjects were necessary at this stage. The outcry that was raised was mainly the charge that the works were sloppy and careless.

Even van Gogh, Gauguin, and Cezanne relied on conventional themes--landscapes, still lifes, and an occasional religious subject. At the turn of the century, Art Nouveau painters, such as Beardsley (Fig. 1), continued to choose themes that occasioned no wrench with the past, and they enjoyed illustrating subjects for which there was an accompanying

text. Surprisingly, even Cubism--seemingly such an abrupt
shift in the first decade of the twentieth century with shockers
like the initial work by Picasso, Demoiselles d'Avignon (Fig.
64)--started with the habits of mind of realism. Cubism's
subjects were figure painting, landscape, still life, and even
portraits. So far the subjects explored were not new.

Not until the second decade of the twentieth century
does modern art become so pioneering as to rank with the
break-throughs of illusionism of the Greek period. This
break-through was in the opposite direction. Without the
benefits of the conquests of either Greek illusionism or that
of the Renaissance and later European art, subjects became
non-subjects; quite contrary to Greek and Renaissance art,
themes were attempted that had no precedent whatsoever.
Moreover, unlike pre-Greek and Medieval non-illusion, themes
were not based on subjects from nature and reduced simply to
a minimizing abstracted style; this art took an unprecedented
step. Picasso and Duchamp proceeded from figure painting
and still-life, and they left figure painting and still-life be-
hind. Kandinsky and Mondrian proceeded from landscape and
left landscape behind. This abstraction created a non-visual
reality for art completely of itself, dangerous territory for
the visual arts!

Always before, landmarks from visual experience gave
the observer some bearings. With the voiding of traces of
natural subjects, necessarily form and meaning had to swell
to fill the gap. At first, the modern public found it difficult
to grasp that the how and why of painting had eclipsed the
what.

Form (the topic of the preceding chapter) partly usurps
the role of subject: lines, shapes, and colors exhibit a
range in abstraction never before attained. There is no
doubt that, in form, modern abstraction is basically different
from all abstract art of the past. Worringer's definition of
abstraction assumed that nonrealism was space-denying.
But modern abstract paintings are not necessarily flat (Figs.
32 and 33). The twentieth century discovers the possibility
of plastic abstraction and of painterly abstraction. In pio-
neering new plastic, coloristic, and textural frontiers, clear-
ly modern abstraction is the beginning of exciting expansion
of form options like those which followed the Dipylon Vase
in Greek art. This revolution seems to be destined to ex-
plore non-illusion as thoroughly as the Greek one explored
illusion. However, one cannot anticipate the traditional form

sequence that occurred in Greece--planar to plastic to
painterly--because plastic and painterly abstraction are be-
ing simultaneously produced.

Meaning (the topic of the succeeding chapter) also
usurps the traditional role of subject matter: intent and con-
tent take on added importance. An art work must justify
its own existence by its expression. Without the security
enjoyed in the past when a work was guaranteed a measure
of significance by virtue of being something or representing
something, today's work is challenged on the basis of whether
it means something. The artist's intention (volition or will)
and the work's expressive content emerge for the public's
scrutiny.

The shift away from subjects even remotely based on
nature, toward an emphasis on meaning, is related to Harold
Rosenberg's concern with a new definition for art that em-
phasizes the will of the artist. In The Anxious Object, he
speaks of the resolve of modern artists "to liquidate art as
a classification of objects and to redefine it in terms of the
intellectual acts of artists.... What is decisive is who does
what for what reason.... Art does not exist. It declares it-
self. The anxiety of art represents the will that art shall
exist despite conditions that might make its existence impos-
sible. Through constant revision of its aims, its techniques,
its scope, modern art had made itself into a discipline rooted
in the free development of individuals. All the traditional
elements of painting have been reconceived in such ways as
to make them completely subject to the will of the artist."[29]

After this redefinition of art as the will of artists,
it is likely that effects will persist indefinitely--descriptive
subject matter may never seem to be so important to the
observer of art. (Probably, subject matter often had been
less important to the artist, preoccupied with executing a
work, than to his patrons and public, who relied on the
identification of items as signposts of meaning.) The de-
velopment of twentieth-century art may rank, along with the
Greek period, as a revolution with perennial repercussions.

Already, some instances of a return to subject mat-
ter evidence a changed relationship between subject and
meaning. For example, following hard on the heels of non-
subject dada works, the Surrealism of the 'twenties depicts
naturalistic subjects--still-life objects, landscape vistas, and
human figures. Because of dada's disregard for subject, the

Figure 32. Picabia: Physical Culture

Figure 33. Kandinsky: Painting, 1914

Surrealist themes are freed to be more at the mercy of the artist's private vision than they might otherwise have been. Again, when de Kooning reintroduced the female figure into his paintings in the early 'fifties, the figure was dominated by the expressive environment of Abstract Expressionism.

Even artists working in styles which never capitulated to the idea of dispensing with subject matter evidence signs of the acquaintance with what was going on in the work of non-subject circles. Chagall and De Chirico, in the early twentieth century, retained subject matter, but themes became a personal vocabulary. At mid-century, Pop artists use mundane subjects to express inner states.

Recently, the very issue of whether illusion or non-illusion, subject or non-subject is preferable seems dated. All of the alternatives are totally valid and simply reflect the artist's various options, as Meyer Schapiro observed over thirty years ago. It is especially clear with current developments that other things matter more than abstraction versus realism. Today, the artist as actor, the work as activity, the audience as participant became challenging ideas.[30] Translated into Gombrich's language, with much current art it seems that <u>doing</u> supersedes all that went before, be it making, matching, or non-matching.

Opposite: Examples of modern abstraction

Chapter IV

MEANING

Meaning is the goal of a work of art. Toward the goal of significant meaning, form and subject matter are the vehicles. For an art work to be successful, the form and subject must be appropriate for the meaning expressed.

Meaning was defined in the introductory chapter as both the artistic intention and the content of a work of art. The theory of intention, as it will be interpreted here, goes back ultimately to Alois Riegl's book of 1893 entitled Stilfragen on questions of style in the ornament of various early peoples (Egypt, Mesopotamia, etc.). In the introduction, Riegl uses the word, Kunstwollen, for the impulse motivating artists and craftsmen.[1] When Wilhelm Worringer reviewed the Riegelian theory (in a passage in Abstraction and Empathy, translated into English) the term Kunstwollen was given as "volition." Volition, as explained by Worringer is not a specific, conscious motivation but a vaguely-sensed, "latent inner demand" which becomes definite as the work takes form and is necessarily modified by the limitations of material and technique.[2] By the concept of volition, Riegl was concerned with demonstrating that it is inappropriate to judge a work by standards irrelevant to the artist's intentions. Riegl at the same time gave the term an overtone of determinism which is anathema today; hopefully, the synonym, intention has a less absolute ring.

There is a fortunate parallelism between the words, intent and content. The definition of content becomes, very simply, the evolved statement of the underlying intent; the two can only be separated from one another artificially because content develops imperceptibly from intention. Henceforth, in this volume, meaning will be considered as a whole.

Erwin Panofsky, in an essay of 1940 titled "The History of Art as an Humanistic Discipline," emphasizes the intrinsic nature of meaning. He says, "Intrinsic meaning ... is the basic attitude of a nation, a period, a class, a

religious or philosophical persuasion--all this unconsciously
qualified by one personality, and condensed into one work."
Panofsky very neatly sums this up by explaining that intrin-
sic meaning is "that which a work betrays but does not
parade."[3] Just as the betrayal of meaning is unconscious,
in literature about art the discussion of betrayed meaning
is frequently not raised separately. Instead, since betrayed
meaning is intrinsic to art works, any discussion of art is
bound to allude to meaning even when the focus of attention
lies elsewhere. In this volume's chapter on form, the sug-
gestion that a certain type of form is compatible with a
given environment implies that one type of form is more ex-
pressive than another of certain cultural attitudes. In the
chapter on subject, the Worringerian idea that the abstrac-
tion of some early peoples communicates a dread of the un-
known involves meaning.

 Now, giving attention explicitly to meaning, it is
clear that both the artist's deliberate and unconscious clues
are only wasted on the insensitive observer. Besides the
artist's role, the beholder must play his part. Gombrich
is concerned with this collaboration of artist and beholder
in the case of realistic art. In an essay in Meditations on
a Hobby Horse, he stresses that what is needed is "skill
not only of representation but in making sense of representa-
tional skills. This duality, this interplay between the artist
and the beholder is a factor often overlooked. We owe its
theoretical formulation from the point of view of psycho-
analysis to Ernest Kris who is my guide and mentor in
these things."[4]

 Gombrich goes on to distinguish between what he
calls the ritualistic versus the aesthetic attitudes:

 It was Kris who first emphasized that the emer-
 gence of what might be called the aesthetic attitude
 to painting--as distinct from the ritualistic attitude
 --brings about a new type of reaction, or, as he
 puts it, of discharge. The connoisseur wants to
 identify himself with the artist; he must be drawn
 into the charmed circle and share in his secret.
 He, too, must become creative under the artist's
 guidance.... Mature art can only grow within the
 institution, as I call it--within the social context
 of the aesthetic attitude. Where this breaks down,
 representation must soon revert to the more
 primitive, more readable conceptual image.[5]

This chapter will trace, through selected examples, the
ritualistic attitude, various stages of the aesthetic attitude,
and then a reversion to the ritualistic attitude. The discus-
sion here expands on the idea of ritualistic versus aesthetic
art. In particular, names are given to a sequence of phases
within the aesthetic attitude and, generally, I develop a
whole cluster of ideas around the initial suggestion by Kris
and Gombrich.

In order to introduce the ritualistic and aesthetic at-
titudes, several paintings with the same type of subject
matter--all portraits--provide a controlled situation. Ob-
viously, any portrait likeness of an individual must be es-
sentially realistic, so the chapter introduces the topic of
meaning via naturalistic art solely. Different steps, from
ritualistic through aesthetic attitudes, distinguish sorts of
meaning under the broader category of realism. (As for
modern abstract art, this frame of reference applies, and
the reader will be able to test the applicability of these
designations to contemporary abstraction after considering
the presentation that follows. Before the twentieth century,
abstraction belonged largely to the primary meaning classifi-
cation about to be developed, the ritualistic; so the subse-
quent stages of aesthetic meaning will not prove applicable
to early abstraction. Mention of the meaning in past ab-
straction is made on pages 85-86.)

Previewing the scope of this chapter, a few sentences
about each portrait will introduce the categories of meaning
they represent: the ritualistic attitude; the descriptive aes-
thetic attitude; the classic aesthetic attitude; the emotive
aesthetic attitude. The first portrait depicts a fourteenth-
century king of France, John the Good, perhaps by a court
painter named Girard d'Orleans (Fig. 34). It is a decisive
profile with firm outline and shading. Such simple defini-
tion, comprehensible even to the uninitiated beholder, ex-
emplifies what Gombrich calls "the ritualistic attitude."
The second portrait, by Piero della Francesca, shows a
fifteenth-century Italian nobleman, Federigo da Montefeltro
(Fig. 35). One is struck immediately by the peculiar ab-
sence of the bridge of the nose (the result of a dueling ac-
cident) and one notices more carefully observed detail than
in the rendering of King John. There are warts and wrin-
kles on Montefeltro's face, and there is a distant landscape
behind the figure. The amount of specific detail places
greater demands on the observer than in King John's por-
trait; the work requires an aesthetic attitude on the part of

the beholder. As the stage of meaning that has been reached
is mainly concerned with description, the inauguration of
aesthetic meaning can be designated "the descriptive aesthetic
attitude."

The third portrait is a representation of Pope Julius
II by Raphael (Fig. 36). Julius is seen in relation to the
space he inhabits, a space which includes other nearby fig-
ures and objects. This step in aesthetic development has
the amplitude that is considered "the classic aesthetic atti-
tude." Fourthly, a Giulio Romano portrayal of Julius' suc-
cessor, Pope Leo X (Fig. 37), places the figure in a simi-
lar setting; nevertheless, it has a quite different mood--there
is a feeling of extravagance caused by the animated drapery
and by the fact that the accessory figures are differently
scaled. This is altogether non-classic in a classic environ-
ment; the tension between what the knowledgeable observer
might expect and what occurs here is expressive and may be
called "the emotive aesthetic attitude."

The fifth portrait is by El Greco and depicts Cardinal
Guevara (Fig. 38). The figure is seated alone and looking
out at us. We sense that Guevara is a nervous individual;
a kind of flickering tension pervades the scene, resulting in
a different sort of emotive meaning. Finally, in a posture
somewhat similar to that in the El Greco painting, Mrs.
Killiaen Van Rensselaer (Fig. 39) sits for an unmoving crys-
talization. The portrait, attributed to John Watson, has a
clarity that strikes one immediately. One is reminded of
the simplicity of the ritualistic attitude in which no sophistica-
tion about art is required of the beholder.

These portraits arouse one's interest in different
ways: they betray different basic attitudes on the part of the
artists; they provoke different types of responses on the
part of the audience. The different attitudes that are sug-
gested by these portraits are useful in interpreting other art
works. In order to explain the terms further, these por-
traits plus additional examples of painting and sculpture will
be called upon in the ensuing discussion.

It might be added, since this brief chapter must in-
troduce the topic of meaning via a limited range of art
works, that architecture will be slighted; however, architec-
ture, too, has intrinsic meaning. Clearly, the basic attitude
conveyed by an Egyptian pyramid is different from that of a
Gothic cathedral.

(cont'd on p. 84)

(Below and opp.): Examples of the ritualistic attitude and the descriptive aesthetic attitude.

Figure 34. Girard d'Orleans (?): <u>King John the Good</u>

Figure 35. Piero della Francesca: <u>Federigo da Montefeltro</u>

(Below and opp.): Examples of the classic aesthetic attitude and the emotive aesthetic attitude.

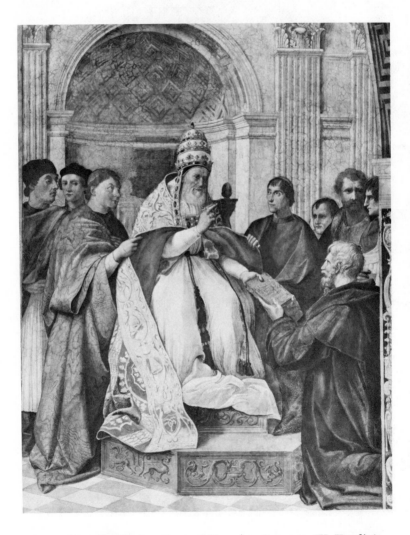

Figure 36. Raphael: Pope Julius (as Gregory IX Handing over the Decretals

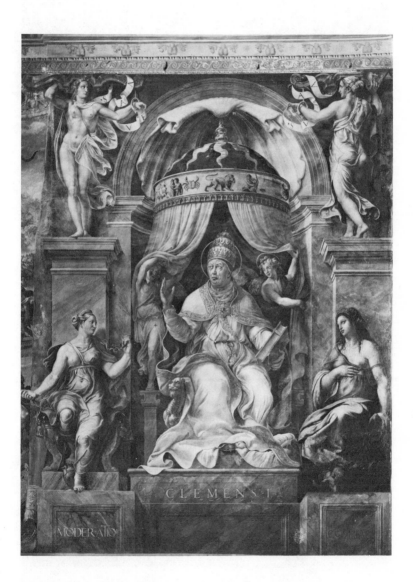

Figure 37. Giulio Romano: <u>Leo X (as Clement I with</u>
<u>Moderatio and Comitas)</u>

(Below and opp.): Examples of the emotive aesthetic attitude and the ritualistic attitude.

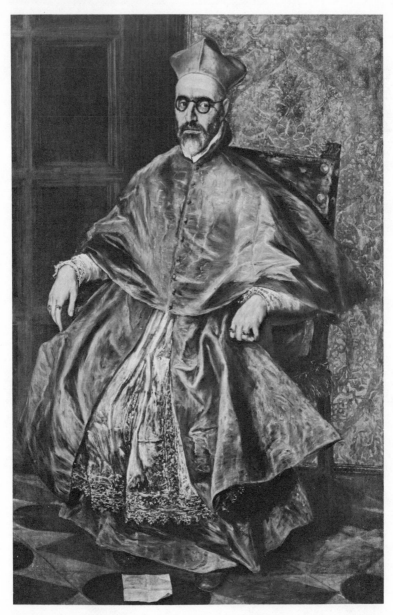

Figure 38. El Greco: The Cardinal Inquisitor Don Fernando Nino de Guevara

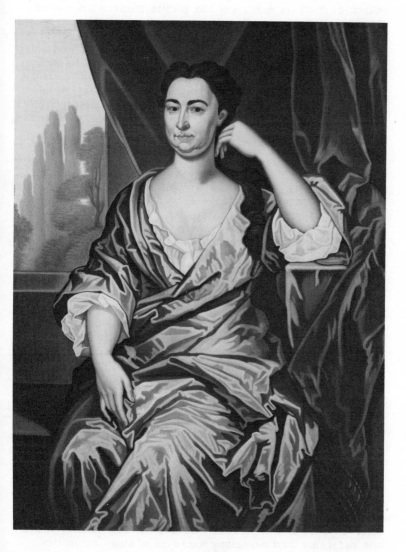

Figure 39. Attributed to John Watson: Mrs. Kiliaen Van
Rensselaer

a. The ritualistic

 The proto-Renaissance King John the Good is one of
the earliest preserved portraits that is devoted to the like-
ness of an individual. There are no trappings of state or
church to distract one from the profile itself. Undoubtedly,
since the likeness is all-important, the features must be suf-
ficiently accurate to have been recognizable to contemporaries;
yet, the handling is so broad and simple that a skilled artist
need hardly have posed John the Good before him to capture
the king's appearance. He might have drawn from memory.
The artist would have relied, of course, on a lifetime of
astute perception of faces; but he could have based this work
primarily on a conception as simple as a remembered image.

 Such a drawing or painting made from memory, or as
if from memory, is traditionally labeled conceptual. Recent-
ly, scholars such as Gombrich have questioned the comfort-
able assumptions about conceptual art and its memory picture
basis. (See page 53.) I have chosen to substitute a term
invented by Gombrich, ritualistic art, because it avoids un-
desirable connotations and encourages desirable associations.
Formerly, the assumption was that the artist is impelled by
what he "knows," as opposed to the case when an artist's
work is perceptual, based largely on what he perceives, or
sees. Conceptual art, according to this theory, employed
mental images. In this way of thinking, for the portrait of
King John, a mental image provided the volition of the artist.
He proceeded to work with careful, thoughtful deliberation,
but every step during the execution was directed toward re-
alizing the objectification of a memory picture. The finished
product would convey the sense of conviction of the rightness
of the mental image. Today, these traditional assumptions
have been revised because psychologists hold that people's
mental images bear little relation to what is called conceptual
art. To get away from the outdated implications of the label,
memory picture, this volume speaks of a style of essence.
To de-emphasize the term, conceptual art, the adjective,
ritualistic, may be substituted.

 One advantage of the label, the ritualistic attitude,
is that it explains more than the method of the depiction of
a king's profile. It reminds one that such art describes
other aspects of a monarch. Because of his station, a cer-
tain deference and ceremony surround a king, no matter
whether his acts deserve it. A ruler, having an arbitrary
or symbolic meaning like that of a hero or saint, can be

appropriately rendered in a ritualistic way. There is nothing tentative or qualified in the ritualistic attitude; it is assured, authoritative, hieratic.

There is an inevitability about ritualistic art. Despite the intellectualizing that necessarily goes into the actual process of executing any work, an artist's efforts are steadfastly directed toward rendering a pre-ordained concept. Preconceptions somehow carry a conviction above what one actually sees and above reason. One does not deny reason, one simply fails to invoke it. The ritualistic somehow bypasses any deliberate thought process; it is not irrational, but a-rational.

One hallmark of the ritualistic stage in art is that it places few demands on the observer. Since the public determines the character of a given art style as much as the artist does, the ritualistic style is necessary where the audience is unsophisticated about art. Most familiar traditions began at this stage and the term, primitive, is often applied to ritualistic art in the sense of the word meaning, literally, first. Barbara Novak distinguishes between a primitive style "having within it the potential for change and development" (what she calls archaic art) and primitive art that does not develop but retains the same character for a span of time (what she calls folk art). [6] The King John the Good belongs to the category of archaic primitive art by virtue of being an early example of a tradition that subsequently developed away from this stage.

It might prove revealing to conjecture for a moment about a hypothetical situation a bit different from the commission for the portrait of King John. What if a court artist decided to ignore his conceptualization of the ruler's appearance and to emphasize instead the man's official role? He might rely on some abstract formula which traditionally in that culture was associated with royalty. He might abandon the essence image sort of fidelity to one ruler's features and submit to the authority of a stylized formula applicable to all kings. This would mean that the artist devoted himself to ritual even more thoroughly than did the artist of the King John the Good. Applying a formula by rote, such an artist submits himself so thoroughly to ritual that his work is removed--that is, abstracted--from nature. Traditionally in art history, abstraction is firmly ritualistic. (Admittedly, with modern art this generalization is no longer valid.)

For an example of a more abstract portrait: in the
absolutist state of ancient Egypt the king was worshiped as
a super-hero, even a god. The requirements of a pharaoh's
portrait did not include individualization; in fact, the artist
was required to make the ruler's appearance conform to a
standard type (Fig. 8). Acknowledging that, by definition,
portraiture resists gross abstraction, this case demonstrates
that there can be less realistic portraits than the profile of
King John the Good.

Several other works may be reconsidered which depict
idealized figures, rather than actual persons, in a manner
sufficiently inclined toward stylization that they belong to the
category of the ritualistic. Glancing back to the illustrations
in earlier chapters, there seems no doubt that a ceremonial
dignity is communicated by planar works exhibiting some
characteristics of essentialism. Each figure seems to have
the quality of an eternal presence not fettered by time and
place. Indeed, the subjects require reverence: a Greek
Kouros (Frontispiece); Benedict and Desiderius, two Medieval
saints (Fig. 5); the Madonna and Child (Fig. 19). Hieratic
subjects, planar form, and the ritualistic attitude perfectly
serve one another.

The King John the Good is the most individualized
figure among those we have just reviewed. It is more in-
dividualized than the Egyptian pharaoh, the Greek Kouros, the
Medieval saints, or the Italo-Byzantine Madonna. But com-
pared with the next three works to be discussed in this chap-
ter's sequence of portraits, the King John is the most sche-
matic. Thus, the King John seems to represent a pivotal
position between the more stylized, ritualistic art and the
more realistic art that--as is about to be seen--permits ac-
commodation to aesthetic considerations. When a sequence
appears to begin at the ritualistic stage, subsequent art can
either remain at this point or travel in one of two directions--
toward more ritualistic stylization or toward more individual-
ization.

b. The descriptive aesthetic attitude

In the case of the Early Renaissance portrait by Piero
della Francesca (Fig. 35), the painting describes Count Monte-
feltro's distinctive profile with firmness equal to the manner
of the portrait of King John. Here, however, there is con-
siderably greater attention to the details of the surface of the

cheek; there are lines and blemishes that indicate careful
study from life. A simple essence image would fall short
of this meticulousness. Further, the artist has included a
landscape flooded with light in the distance. Recourse to
the knowledge of linear and atmospheric perspective gives
away the fact that Piero was an avid student of visual reality.
Although the profile has a ritualistic simplicity, supplemen-
tary detail in the foreground, the background recession and
unifying light are based on visual observation.

Necessarily, any artist who works from life asks him-
self questions: Where is the light source? How distant is
the object from the observer? Does another vantage point
afford a better view? Visual observation is open to question
in a way that ritualistic recital is not. When the artist
wrestles with these problems, he comes up with a product
in his art which is, in turn, more challenging to the public
than ritualistic art had been. The beholder must "become
creative under the artist's guidance," as Gombrich put it. [7]

Piero and his patrons, such as those in Montefeltro's
court in Urbino, were devoted to the study of the external
world. Some were especially interested in the sciences of
anatomy and perspective. Piero himself, toward the end of
his life, wrote a treatise on perspective. Sometimes, in the
intellectual atmosphere in fifteenth-century Italy, the concern
for scientific visual realism was so thinly disguised that an
altarpiece became a demonstration of anatomy and perspective
more than an expression of religious sentiments (as in
Pollaiuolo's St. Sebastian, Fig. 27). Once visual truth be-
came an Early Renaissance artist's concern, he found that
the creative process involved continuing adjustments as the
facts of the visible scene shifted, and adjustments as his
understanding of the scene increased. Visual accuracy al-
ways is a demanding, elusive goal; any artist finds himself
redefining "reality" and modifying his plans.

As has been said, a style may warrant the label of
"realism" when a problem of verisimilitude becomes so ab-
sorbing that it is a goal in itself. [8] To this interpretation
of realism can now be added the notion that styles so labeled
fall under the heading of the descriptive aesthetic attitude
toward art.

To complicate matters, an artist seeking visual real-
ism may be reluctant to abandon some attributes of the
ritualistic art of his predecessors, or he may strive for

some qualities that succeeding artists will accomplish. Using
the Montefeltro as an example of the former, despite the fact
the observer is challenged to bring to the work an aesthetic
attitude, Piero sought to retain a degree of ritualistic sim-
plicity because the panel had a commemorative role. (It is
half of a diptych that may have been intended to honor the
recently deceased Countess of Urbino. 9) Accordingly, Piero
--being conservative for his date--employed a ritualistic
profile that was typical of earlier decades than the 1470s.
The profile is reminiscent of the King John the Good from
the 1350s, in the proto-Renaissance. Furthermore, Piero
placed the figure so that it has no connection with the land-
scape. He did these things because he wished to impose
some elemental certainty upon his rendering of the appearance
of things. Yet, once inquiry into descriptive accuracy is un-
dertaken, the simple essence image is no longer possible.
Here, the evidence of foreground details and background il-
lusion of depth testify to the study of nature that character-
ized Piero's inquiring state of mind.

 For an example of another possibility--progressive
tendencies--Piero, despite his realism, can be interpreted
as a precocious artist striving for qualities of idealization
that anticipate the next topic heading, the classic aesthetic
attitude. Sidney Freedberg, a key interpreter of Italian
Renaissance content by means of a searching examination of
form, explains that with Piero, "Intended precise natural
description coexists effectively with intellectually formulated
principles of geometric order. Within each seeming accident
of appearances Piero seeks out, or invents, a rationale of
form. Whole physical beings, with their multiple execre-
scences, seem to be constructed by a process of building
outward, in successively more minute geometrizing steps,
from a central geometric core. Actuality and intellectual
analysis are simultaneously satisfied by this process. How-
ever, the two ambitions that they represent are absolutely
far apart."10 To put this into the present frame of refer-
ence, descriptive visual realism and ideal generalization are
both satisfied. But, as Freedberg says, Piero does not
achieve complete success in reconciling the two goals. "De-
spite the relentless step by step logic of transition that
Piero makes between them, the separateness of their ex-
tremes is always sensible. They are not harmonized upon
a middle ground"--as will be the case in the High Renais-
sance soon to follow. 11

 Thus, the Early Renaissance Montefeltro, which has

been designated as belonging to the category of meaning called descriptive, seems to straddle territory between the ritualistic (of the proto-Renaissance), and the classic (of the High Renaissance). Similarly, in terms of form, one has to admit that the painting exhibits a combination of formal types. The silhouette of the face is linear-and-planar, yet the bust as a whole has a tangible volume to it. As for the background, the landscape is recessional without being really plastic, and this vista is so luminous one might also speak of precocious painterliness. Obviously, this is not a clear example of a single form category.

Other examples of the descriptive aesthetic attitude are accompanied by hybrid or transitional form. This is an explanation for the linear-and-recessional form in the drawing by Schön (see pages 11-12 and Fig. 2). For another example: a descriptive approach with a tendency toward planar or plastic foregrounds, recessional middlegrounds, and painterly backgrounds occurs in the style called "Luminism" in nineteenth-century American art. Representing this case of composite form are shoreline scenes by Kensett, Lane, and Heade in which there often is a linear boundedness to near-by objects on the beach; recessional axes of ocean waves or ships in the mid-distance; and either hazy or dazzling light enveloping detail in the background near the horizon.[12]

Returning to the case at hand, Piero della Francesca's descriptive art can be considered to be transitional--capable of some conservatism and, at the same time, progressively laying the foundation for the High Renaissance, that style which can be called classic.

c. The classic aesthetic attitude

The third portrait is a High Renaissance painting of Julius II, by Raphael (Fig. 36). As in the prior portraits, there is a correct likeness, but the pose is different, a seated figure on a throne seen from a three-quarters view. In addition to the pontiff, there are other figures and a kind of stage-like space for them to inhabit. Clearly the artist has placed the figure of the pope in relation to other space-inhabiting forms, and the artist is concerned that these forms appear in a lucid setting. Through light-and-shade and through perspective, we are convinced that the figures are within an ample environment rather than before a backdrop.

As for the rendering of each individual, Freedberg says that
Raphael "clarifies the geometry he finds implicit in the form
of whole head and of features of the sitter.... The head is
transcribed as a unit of emphatic, including, plastic form
within which the features take their place as clear articulat-
ing parts."[13]

 This consistent, unified organization of a thoroughly
plastic scene is a more fully developed statement of rational
description than the Piero della Francesca portrait. There
is no doubt that Raphael's method betrays an overall confi-
dence in the ability of human reason to cope with man's
environment. Indeed, the artist effectively organizes three-
dimensional space through the science of mathematical per-
spective; the deliberate shading of the figures adds to a
sense of mass; and the modeled heads are, in Freedberg's
words, "cogent" and "impactful." All aspects of the painting
affirm that the sitters and the artist are able to organize
their world through reason. "In biographical terms, these
portraits symbolize the way in which the high classical cul-
ture of Julian Rome is intellectually willed and intellectually
achieved. It goes without saying that the state of mind and
the character of behavior of these persons, as Raphael rep-
resents them, is in part a fiction: but it is a fiction con-
trived by the artist and by his contemporaries jointly and
endorsed by them."[14] Plastic visual realism and an opti-
mistic vote of confidence in human reason go together.

 Obviously, Raphael cannot entirely idealize because
he must record imperfect human features. A better vehicle
for idealization is the theme of the Madonna--symbol of
human perfection. In his many well-known paintings of this
subject, Raphael demonstrates the deft blend of the real and
the ideal that deserves the wonder of posterity. The painter
is so well-versed in the anatomical facts of the structure of
the face that he can accomplish correctness at the same time
that he creates an imagined perfection.

 The term, classic, links the High Renaissance with
the style of Classical Greece.[15] Two examples of this stage
of Greek art have already been seen, the Lemnian Athena by
Phidias (Fig. 17) and the Doryphorus, or Spearbearer, by
Polyclitus (Frontispiece). Of the two, the subject of the
goddess, Athena, is especially appropriate for rational art:
Athena is the goddess of wisdom, the very materialization
of the importance of reason. Both of these statues exem-
plify the classic union of the rational and ideal. When

seeking ideal beauty through the rational, the Greeks natural-
ly thought in terms of mathematical proportions. Thus, the
proportions of the facial features conform to a canon, or
rule; and the vertical dimension of the head is a fraction of
the total height of the figure. In the slightly different term-
inology that Byzantine artists have passed down to us, the
face becomes a module upon which the height of the entire
figure is based.[16] Even today, Greek canons of proportion
provide a helpful rule of thumb for the artist working from
life, and they unconsciously shape our notion of what con-
stitutes beauty in the human figure.

The Greek classic attitude provides an appropriate
opportunity to return to the question of the relationship of
intention to content. One might legitimately ask whether the
Lemnian Athena is a deliberate statement of an existing idea
of perfection or whether the statue, upon taking form, helped
contribute to the idea. According to this avenue of thought,
artistic volition may be the seeking for something that re-
mains unclear until it is found; in fact, the art work gives
form to--formulates--the idea. Perhaps there is a measure
of truth in this position: in the words of the Roman Quintilian
speaking of another Phidian statue, "The Zeus of Phidias ...
has added to our conception of religion."[17] An artist may
either be impelled by an existing idea, one already given
shape by the work of another artist, or he may be impelled
to search for a vaguely-sensed idea. When he states his
meaning, he may have also found it. Sir Herbert Read main-
tains, taking a broad view of the development of civilization,
that the icon always precedes the idea: "What has not first
been created by the artist, is unthinkable by the philoso-
pher."[18]

Another key example of the tradition with which one
associates the word, classic, is the style fostered by the
French Academy of Art. In the mid-nineteenth century,
Ingres carries on this tradition in works such as the portrait
of Monsieur Bertin (Fig. 22). This painting is certainly
linear-and-plastic in form; it follows that this three-dimen-
sionality indicates a visually realistic approach to the subject,
and the attitude betrayed by this approach is partly descrip-
tive; but, additionally, there is present here an idealization
that warrants the label, the classic aesthetic attitude. It
happens that a preliminary drawing by Ingres of this sitter
exists. The comparison of the drawing with the painting
confirms what is sensed in the finished work alone; the es-
sence of the individual's actual appearance is distilled into
perfected proportions and regularized features.

A goddess and an athlete of Classical Greece, a pope
of the High Renaissance, and a nineteenth-century French
businessman: all share elements of style--plastic form,
visually realistic subject, and the classic aesthetic attitude.
Many other related examples occur in European history. As
a matter of fact, the classic aesthetic attitude, occasionally
based on specific Greek models and always definitely plastic
in form, has never been totally absent from Western art,
from the time of Giotto through the nineteenth century.

d. The emotive aesthetic attitude (physical and psychic)

A few years after Raphael's Julius II portrait in the
Vatican, his pupil Giulio Romano painted a fresco of the next
pope, Leo X (Fig. 37), for another chamber in the papal
palace. Allegorical figures flank the pontiff, and drapery
swirls in an animated fashion. The emphatic shading gives
a metallic hardness to all surfaces--even to fabric and flesh.
One can hardly escape the notion that Giulio set out deliber-
ately to violate the calm and confident classicism of the ren-
dering of Julius (with which he was very familiar). Even
the abrupt shift to a smaller scale for the framing figures
violates expectations. The basic similarities between the
two works only sharpen the contrasts. Whereas the plasticity
in the earlier work supports a lucid, composed, quiet order;
the later work displays an unclear, shifting, cacophony. One
might say that plasticity has been employed to undo what
Raphael had done, and in this way Giulio assumes the role
of an "anti-classic" Mannerist.

Restlessly, the sculptural figures by Giulio twist and
turn; yet they seem less alive, less impelled by an inner
motivation than the figures in Raphael's Julius. As Freed-
berg explains, Giulio has imposed his will on the figures
from without; he has not projected his ideas so that they
emanate from the forms he created. As if he were a pup-
peteer, "the movement of the figures is determined for them
by Giulio as absolutely as if they were marionettes, or truly
statuary."[19] The figures lack the impression of a relation-
ship between thought and accompanying action that is present
in classic art. Here, hyper-plastic form negates the classic
and pushes beyond reason.

This example of the emotive aesthetic attitude betrays
the fact that confidence in man's ability through reason to
order his world is disturbed. Indeed, by the time this work

was done, in 1521, the dissolution of the High Renaissance
was being sensed by astute observers. Although the Prot-
estant Reformation was barely started, it was one threat
among many to the culture, wealth, security, and power of
Rome. In this painting, Giulio Romano seems to be suggest-
ing that outside forces can manipulate men, forces defying
reason. He achieves this content through exaggerated plas-
ticity, unexplained animation, and surprising juxtapositions
of scale.

Turning to the next portrait in the sequence, here is
a quite different case, yet the work may also be classified
as emotive. This Late Renaissance oil painting depicts the
Cardinal Guevara (Fig. 38) and was painted by El Greco.
There is a seated figure in a chair that is turned at a slight
angle, and there is a piece of paper that has fallen to the
floor. The sitter's arms and legs appear drawn-in and
tense; the hands do not appear relaxed. A shimmering, elu-
sive light glances off the Cardinal's robe. As for the facial
expression, the thin lips and shifty gaze suggest a slender
thread of self control. This man seems at the mercy of
some sort of pressure; in fact, the Cardinal was an Inquisitor
and was an instrument of contemporary religious suppression.

El Greco was expressing not only the emotional ten-
sion of the Cardinal but his own personality and the character
of the time. El Greco was two generations younger than
Raphael and Giulio Romano, and the complexion of Europe
was entirely changed. Things that Raphael's clear-eyed
world had barely hinted, and that Giulio Romano has sus-
pected and lived to see, had shattered High Renaissance con-
fidence. The acceleration of the Protestant Reformation and
the sack of the city of Rome by Spanish and German troops
had unsettled much that the High Renaissance took for granted.
Among other things, the confidence in man's ability through
reason to order his world had been destroyed.

Both the Giulio Romano painting and the El Greco
painting have been described as emotive, yet the two are
distinctly different. The contrast between them is more
basic than the dissimilarities of the settings depicted and the
fact that one is part of a large frescoed wall and the other
is an easel painting in oil. Giulio Romano's content is ex-
pressed by physical means--emphatic plasticity and actual
motion. El Greco's meaning is conveyed through flickering
light and color and seems to hint of introspection and inner
unrest. Rather than being physical, it is psychical.

The psychic is here communicated by painterly form. Since El Greco was a greater distance from High Renaissance Rome than Giulio had been, both geographically and chronologically, he was in a freer position. There is no question but that this work demonstrates the ability of painterliness to suggest non-material things; the flexibility and subtlety of painterly form is shown to be especially appropriate to express more than appearance. Painterliness can convey a sense of the world of emotions and spirit wherein thoughts are vaguely defined and elusive. Painterly suggestion hints of psychological struggle.

Furthermore, painterliness is not confined to the rules of chiaroscuro and perspective (as plasticity is); the emotive artist, feeling that each experience is unique, is repressed by rules. In this portrait, the paint is handled in a way peculiar to El Greco, with restless strokes and the effect of wavering light, as if the scene were beheld in reflected firelight. It is a highly personal technique. Painterliness has this capacity to provide sensitivity; it expresses the uniqueness of experience.

One concludes that emotive art may be considered to fall into two categories. On one hand, a work may appeal through the five senses, being what one might call physically "sensuous." Such is the Giulio Romano Leo X in which plasticity makes a strong appeal to the sense of touch, and emotion is equated with motion. On the other hand, a work may involve experience of the spirit and may provoke the observer's sixth sense, intuition. The El Greco is more of this character; the painting suggests the inner turmoil of the Cardinal. Windy gesticulation and inward unease have in common that both depart from the classic.

Other examples of manifestations of the emotive attitude will support this interpretation; some are more explicit and plastic, some more implicit and painterly. In the Hellenistic statue of the Laocoön and his Sons, the figures are vainly struggling to prevent enormous snakes from strangling them. (The Frontispiece includes a detail of the tormented features of Laocoön.) Much is comparable to the Leo X painting--bold plasticity and a diminished scale for the framing figures; only here the vigorous activity needs no explanation. In this case, the senseless penalty imposed by the gods is reinforced by both tactile and textural exaggeration. The sculptor draws one into the world of the episode. One feels the volume of the shapes and the rippling, painterly

surfaces. Along with these efforts to convince one of the tangible presence of the scene, one feels an estrangement between thought and action that is a clue to the anti-classic, physical variety of the emotive attitude.

In the case of the seventeenth century, emotive art is called Baroque. A supreme master of the sensuous variety of Baroque art is Rubens. He treats religious, allegorical, and mythological subjects, alike, with an earthy lustiness. For example, when he painted a Crucifixion, as his Coup de Lance, the focus is on the physical struggle, not on the spiritual meaning of the scene: the blow of the lance, the writhing of the thieves, the agitation among the observers. Rubens builds his composition with volumetric shapes. His assured, brilliant, painterly execution is legend.

In the nineteenth century, emotive art is called romantic. Delacroix was the acclaimed leader of nineteenth-century romanticism in France although he objected to the term because it implied impetuousness of execution which he said did not credit the planning that preceded his rapid, painterly form. Obviously, painterly art requires thoughtful planning and care in execution, but the effect achieved conveys a sense of spontaneity and a sense of something beyond mere reason. In certain instances, Delacroix has a sensuousness that warrants comparison with the Rubens-type of emotive art. For example, he painted a legendary, Eastern potentate languishing on a couch while before his eyes slaves set fire to his palace and kill all the women and horses he has loved (Sardanapalus). What more sensuously compelling vehicle can one imagine! On the other hand, in his quieter paintings, such as the portrait of Chopin (Fig. 23), his romanticism is turned to the penetration of character. Like El Greco's Cardinal Guevara, this seems more psychic than physical.

e. Reversion to the ritualistic

Swinging full circle, a concluding portrait of Mrs. Kiliaen Van Rensselaer (Fig. 39), thought to be by John Watson, contains, at least superficially, resemblances to the pose of Cardinal Guevara. Indeed, the elegant posture ultimately can be traced back to the same source that El Greco relied upon--to Titian and the Venetian High Renaissance. In the case of an artist working in America, the route the Venetian manner had traveled is quite remarkable. In the

early seventeenth century, Rubens had been influenced by the
Venetians when he was in Italy; returning to Flanders, he
passed on this style to his pupil Van Dyke. Van Dyke went
to England to work, where his elegant depictions of the Brit-
ish nobility became the model for that society. When colo-
nists in America strove to emulate the refinements of Euro-
pean culture, a prominent model was the typical English por-
trait.

But something has happened at this distance from the
original invention of the mode. American portrait painting
betrays that it is a reproduction of a prescribed pattern
rather than an expression arising from the situation at hand.
The artist has relied on a formula for upper-class refine-
ment. There is a curious return to the crystalized, time-
less qualities in paintings like that of Mrs. Kiliaen Van
Rensselaer that can be called ritualistic.

Different as they are, the eighteenth-century Mrs.
Rensselaer and the fourteenth-century King John the Good
can be said to belong to the same meaning classification;
that is, they both are ritualistic. And, in form, after ac-
counting for obvious dissimilarities in pose, one discovers
that the figures in each case are relatively linear-and-planar.
To point up the linearity in the American work, observe what
has happened to the drapery surfaces (which in El Greco had
been so painterly); light and shade has become a formula ap-
plied by rote. It has little relation to actual light conditions
or to this artist's personal sensibility; it is a stylized
schema.

Why has this reversion to the ritualistic taken place?
It is Gombrich's contention that the social setting must ac-
tively sponsor the visual arts, providing the artist and his
audience with training in creating and recognizing sophisti-
cated visual expression. When the social context of the
aesthetic attitude breaks down, "representation must soon
revert to the more primitive, more readable conceptual
image."[20]

The example Gombrich selects is the late sixteenth
century, comparing Venice with London:

> Nobody would seriously contend, I believe, that the
> mind of Shakespeare's audience was necessarily
> more primitive than that of Titian's public. In fact,
> Shakespeare even provides proof that the thrills of

visual projection were familiar to his audience;
think of Hamlet and Polonius talking about the
cloud that is shaped like a camel, or of the ma-
jestic image of the changing shape of clouds in
Antony and Cleopatra. But through lack of oppor-
tunity Elizabethans could not paint such complex
pictures (could they even have read them?). Com-
pared with the miracles of Titian, their portraits
look like stuffed dummies.[21]

The English awaited the arrival of Van Dyke in the 1630s,
the necessary catalyst bringing British artists and public to
that level of appreciation called the aesthetic attitude. And
in the eighteenth century, Americans like Benjamin West and
Copley were drawn to England in their search for a style
beyond the home-grown manner of Mrs. Kiliaen Van Rens-
selaer.

f. Different interpretations

 Just as scholarly thought concerning form has been
rich in theories consisting of dualisms, the theory of mean-
ing has its share of polarities. Among these are Frankl's
Being versus Becoming; Sachs' ethos versus pathos; Roths-
child's analytical versus sensational.[22] Additional terms en-
countered include noumenal versus phenomenal; conceptual
versus intuitive; thought versus feeling; and, simplest of all,
cold versus hot. Actually, these alternates are mostly rep-
etitious, saying the same things with different emphases.
To sum them up, one might select the most elementary. In
a lecture at the Library of Congress in 1949, Curt Sachs
attempted to cut through the obscurity of fancy language and
use clear, everyday words--cold and hot. He explained,
"Hot artists stress emotion, passion, frenzy, ecstacy, while
colder masters hate the display of emotion and ignore or
temper down all vehement passion."[23]

 These various polarities are, in the main, analogous
to the classic versus the emotive aesthetic attitudes this
volume sets forth. It would appear that the earlier stages
isolated in this chapter, the ritualistic and the descriptive,
are, by implication, traditionally assumed to be preliminary
steps toward the classic (by whatever name it is called).
Today, with our predisposition toward primitive schemata
and our acclaim of pioneering innovations, I think it is ap-
propriate to grant separate status to the steps toward the

platform where the classic versus emotive are the protago-
nists. After attaining this platform, obviously the classic
and emotive can alternate. Only when the cultural support
collapses does art revert to the ritualistic.

 The agreement of these various overlapping theories
cements certain notions set forth earlier. First, there is
a consensus that, in Sachs' language, cooler art precedes
warmer art. To Sachs, the beginnings of art are really
cold, whether considering the art of early peoples or con-
sidering children's art. With children, "A man they draw
would at best be 'being' but neither acting nor feeling; the
sun, a circle would radiate beams around it, might perch in
the sky, but it would not light the scene or make objects
cast their shadows."[24] Second, since the evolution of a
period goes from cooler to warmer, at a given moment one
can expect all of the visual arts (architecture, painting, and
sculpture) to register the change in temperature.

 It happens that certain media are more suitable to
one kind of expression than another. Architecture is cooler
than painting, for example. A cooler period will naturally
be a friendly climate for architecture to thrive in. Thus,
the Italian Renaissance was a more congenial climate for
architecture than the Baroque period, which, being warmer,
was suited to painting. The nineteenth century, a very
warm one, was good for painting, less good for architec-
ture.[25]

 Moreover, certain attitudes, such as classic versus
emotive (or cool versus warm), are best expressed by cer-
tain types of form. That is, planar form, plastic form,
and painterly form each happens to thrive in certain creative
climates. Finding a simple polarity from among the portrait
sequence of this chapter: the classic Raphael Julius II
is relatively plastic; the emotive El Greco Cardinal Guevara is
more painterly. Adding the preliminary way-stations de-
veloped in the chapter: the ritualistic King John the Good
is distinctly linear-and-planar; and the Piero della Francesca
Montefeltro has a composite form testifying to the exploratory
drive of the descriptive stage. Following the classic plas-
ticity of Raphael's Julius II, the anti-classic Giulio Romano
Leo X is sending up contradictory signals, being plastic in
form and yet emotive in attitude. The struggle is resolved
in the El Greco Cardinal Guevara, where painterly form and
emotive meaning support one another.

One's understanding of twentieth-century art is increased by this conclusion that certain types of meaning are best expressed by certain types of form. Whereas in the case of early peoples, abstraction had been characteristically linear-and-planar and naturally was ritualistic in attitude, today non-illusion may be plastic or painterly as well; and-- one may guess--the range of underlying meaning has correspondingly expanded. In our day, plastic abstraction often may be described as being classic, and painterly abstraction often deserves to be labeled emotive. No longer are there any limits on the expressive potential of non-realism.

Taking a different tack, at each stage of meaning there is a struggle between the attractions of form, subject, and meaning. A ritualistic work is likely to be somewhat subject-oriented, as evidenced in the driving concern for the very essence of the item depicted; the artist's obsession with subject is especially intense because he is struggling to make an object appear particularized. Contrarily, the origins of art in essences tend to reduce the subject to a general schema, or to formalism.

With the descriptive stage, the artist is still subject-oriented. In this case, the emphasis is upon the visible appearance of the object depicted, and this encourages fidelity in precise detail. Nevertheless, the reliance upon scientific concerns, such as anatomy, perspective, and illumination, contains certain formalisms of its own.[26] The classic aesthetic attitude, because it seeks discipline and because of the specific influence of Greek technique and composition, is inclined to focus on form; yet a rival claim--to rank human values above all--places the focus on content. Finally, the emotive aesthetic attitude, outwardly relishing sensation or inwardly seeking spiritual revelation, seemingly devotes itself especially to meaning; yet the narrative (subject) and the technical means (form) may mobilize all aspects of art to create the impact of emotive works.

Chapter V

PREDILECTION

At the outset, it was said that group styles are commonly designated according to the date or place of their origin. Having already discussed form, subject, and meaning largely in terms of chronology, the effect of geography upon style now requires consideration. It is time to make note of an underlying geographical schism in European art history.[1]

A cursory glance at the offering in art history in a university catalog will usually reveal a series of courses in Italian art, on the one hand, and northern art, on the other, divided into such periods as the Medieval, the Renaissance, and the Baroque. In regard to earlier centuries, the terminology is different; one speaks of Greco-Roman art, on one hand, and Teutonic, Germanic, or Nordic art, on the other. This usage recognizes an unmistakable cleavage between Mediterranean art styles and trans-Alpine styles.

Why should there be such a schism? One hesitates to suggest innate differences in ethnic groups, as certain nineteenth-century historians, such as Hippolyte Taine, did; alternatively, one must conclude that multiple circumstances conspired to develop distinctions. For numerous reasons, the early history of the Mediterranean world was separate from that of the north and markedly different. Because of geographic, economic, political and religious factors, Mediterranean culture developed a certain regional character in the time of the Greeks. Similarly, a germanic cultural heritage was developed in the Teutonic peoples of the first millennium A.D.

Important for the consideration of subsequent art styles is the fact that once cultural patterns are established, society presents a stubborn resistance to change. "Every society functions like a gyroscope to hold the course despite the random private forces of deflection."[2] This apt phrasing

by George Kubler perfectly expresses the theme of this chapter. Another art historian who recently addressed himself to this problem is James Ackerman; he explains that, "If German art is German, it is not because (of) a mystical German Spirit," but because of conservative pressure exerted by society.[3]

Ackerman stresses that a culture's very definition of art is based on past art, so development must always be considered by the contemporary individual as steps away from something rather than steps toward something. After all, no one in a culture, not even the most restless, visionary artist, has the benefit of foresight as to style development—one can only look back with certainty. Thus, the style boundaries based on the past, prescribed by the society within which the artist moves, expose traditional predilections. Cultural conservatism accounts for the persistence of certain ancient Greco-Roman traits that, until modern communication and travel, were often especially conspicuous in art under the influence of Italy. The same retarding effect accounts for the distinct, northern character that repeatedly appears in German art.

One of the differences between south and north, going back to pre-Christian times, was the fundamental outlook on life. Thus, when Christianity came to each region, the existing philosophical attitude it built upon was not the same. Since, overall, the majority of art works have religious roles, this difference in outlook inevitably affected the "intrinsic meaning" in both the pagan art and the Christian art of each region.

What is the essential character of the philosophical cleavage? On one hand, the attitude among the ancient Greeks which appears to have predominated, at least from our perspective, was an assumption that man and the forces behind man's world were basically good; the Greeks felt comfortable and familiar with their gods. True, there was a darker side to the Greek nature, but it seems largely held in check. Overall, the fact that gods had weaknesses, faults, and even vices, simply served to underline the closeness of man to god. There was a relative absence, in the Greek's thinking, of a need for redemption. On the other hand, the pagan northerner of early times did not share this confidence and familiarity with the gods. Compared to the Greek attitude, he felt helpless in face of countless unknown evils, spectral images, and monsters. He was consumed with the

certainty of an inevitable doom. Putting this divergence of
outlook into the context of the chapter on betrayed meaning,
Greek culture was confident in man and therefore classic;
the northern attitude, being less secure, was emotive. Ac-
cording to the metaphor suggested by Worringer, the north-
ern sensibility was a "feverish hysteria"; the southern sen-
sibility represented a "normal temperature" in which con-
fident man was capable of undertaking to impose order on
his world. 4

 Curt Sachs relates the mythological contrast of south
and north to his artistic duality of ethos and pathos:

> Hellenic mythology, in its unworried serenity, if
> not beatitude, had indeed the proper atmosphere
> of ethos styles. But not so Nordic mythology.
> Far from perfection, sereneness, or permanence,
> its scenery is wild and cheerless and its events are
> stirring, strange, and even exotic despite all actual
> or alleged ties of consanguinity. Everything is im-
> moderate, extreme: ice and fire have created a
> world inhabited by tiny dwarfs and by giants so
> huge that two of the gods, Loki and Thor, once
> passed the night in the thumb of one of their mit-
> tens. Muscular strength is unbelievable and un-
> believable is the capacity of stomachs: Thor, the
> thundergod, would eat an ox, eight oversize salm-
> ons besides the cakes prepared for all the women,
> and he would drink two barrels of mead. There
> is action all the time--galloping, fighting, hunting,
> storming. And far from being serene, Nordic
> mythology is deeply tragic and death-conscious.
> Odin, father of the gods, gives one of his eyes for
> winning insight into the future; and the future he
> sees is impending disaster: ragnorok, the Twilight
> of the Gods, the end. 5

 Taking two representative examples of art--one south-
ern one northern--from the period before the advent of
Christianity: if one were to choose a single work to repre-
sent the pre-Christian Mediterranean bias, the outlook might
be best summed up by the Phidias Lemnian Athena (Fig. 17).
The Greek spirit flourished in the plasticity natural to sculp-
ture, in the visually realistic human subject, and with the
aesthetic attitude that is called classic. A pertinent example
of the northern bias is a pagan image of a dragon head (Fig.
40). Although this comes from a much later date, the ninth

Figure 40. Animal
Head

Example of the north-
ern predilection in
pre-Christian sculp-
ture. See Fig. 17
for the epitome of
the southern predilec-
tion in pre-Christian
sculpture.

century A. D., Christianity has not yet affected the Scandina-
vian art tradition that produced it. The sculpture makes a
striking contrast to Phidias' Athena: it is testimony to the
northern imagination not only in the fantastic animal subject
but in its function of scaring away invisible evil spirits.
Constrasting also is the linear elaboration which differs
from the plasticity of Greek art.

 The character of Greek art persisted in spite of the
passage of time and the advent of a new religion with en-
tirely different precepts. It will be helpful to review quick-
ly the succession of styles that followed. After the Clas-
sical stage of Greece, the southern predilection refused to
give way entirely although there was, during the Hellenistic
period, an increasing taste for painterly wall paintings and
for sculpture with dramatic subjects and emotional meaning.
When the Romans prevailed in the Mediterranean world, they
inherited the Greek artistic predilections. In fact, the mo-
mentum of Greco-Roman culture was so great that the new
eastern religion of Christianity was Romanized when it ar-
rived in the area. Eventually, Byzantine culture superseded
the Roman in the region. Having an easterly capital city,
an eastern version of Christianity naturally developed, but
the traces of Greek artistic bias are still to be found.

 About 900 A. D., there is a strikingly Grecian char-
acter to the illumination of David Composing the Psalms

Example of the persistence of the southern
predilection in a Christian manuscript.

Figure 41. David Composing the Psalms

(Fig. 41) from a Byzantine manuscript known as the Paris
Psalter. This work indicates that the Greek knowledge of
those tools of plastic visual realism--anatomy and foreshort-
ening--had not been forgotten although they persisted by rote
rather than by being refreshed through direct observation of
nature. It is hard to believe that considerably more than a
thousand years separates this work from the Lemnian Athena.

The northern predilection also persisted. When mis-
sionaries converted the northern peoples to Christianity, the

old cultures of the north could not be supplanted with the
entire fabric of the Mediterranean one, so Christian art
bears the impress of native predilection. The Irish enthu-
siastically adopted Christianity and became missionaries
themselves; yet this manuscript illumination of St. Luke,
done for an Irish monastery in Switzerland (Fig. 42), seems
far removed from the Mediterranean-based manuscript page.

Figure 42. St. Luke

Example of the per-
sistence of the north-
ern predilection in a
Christian manuscript.

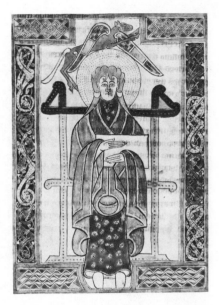

By Greco-Roman standards, this St. Luke is hardly human;
he is but a slight evolutionary step away from being a fan-
tastic being like his pagan contemporaries--Norse dragons.
There is a free play of fantasy in both Norse sculpture and
Irish painting, and they are both linear-and-planar. These
characteristics distinguish them from the more visually re-
alistic subjects and plastic form of sculpture and painting
under the influence of Greece.

 Territory between the northern reaches that produced
the two trans-Alpine examples and the Mediterranean penin-
sulas had contact with both cultural traditions. France is
an important middle ground. Rome had impressed its ways
upon Gaul more than upon other colonial outposts, and in
the ninth century the Frankish king Charlemagne made an
effort to import Roman ways into France. On the other
 (cont. on p. 108)

Figure 43. <u>St. Matthew</u>, Gospel book of Charlemagne

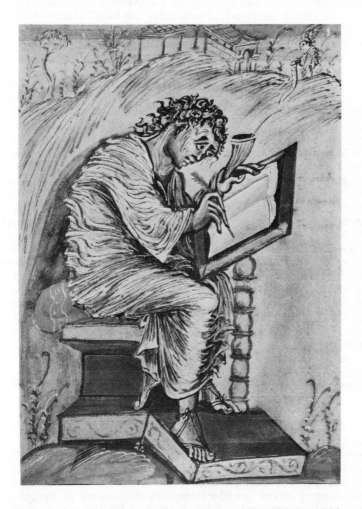

Figure 44. St. Matthew, Gospel book of Archbishop Ebbo of
Reims

hand, Norsemen settled the French province of Normandy,
and Germanic ways penetrated the northeast of France. Per-
haps one clue to the subsequent importance of French cul-
ture is that it managed, from early Medieval times, to par-
take of both cultural traditions. While to a degree the
adopted child of the south, France kept contact with the
northern spirit.

A clear example of this richness in French art can
be found in two ninth-century manuscript pages that are de-
rived from a common source. Two versions of St. Matthew
(Figs. 43 and 44) are clearly based on late antique Roman
art from about 400 A.D. which was known in the north via
copy books--guide books for artists illustrating routine sub-
jects such as saints and Bible figures. One St. Matthew
originated in Charlemagne's own "Palace School" at Aachen
and is quite southern in feeling. It is so near to late Roman
prototypes that some authorities feel that the painter was
Byzantine; others feel that the artist may have been trained
in Italy. In any case, the St. Matthew is broad and volumi-
nous in form and rational in expression. The artist of the
other St. Matthew, from Reims, transformed his late Roman
model into a work that is distinctly northern. It is more
linear and less visually realistic in subject. As for meaning,
it provides a fine example of Worringer's "feverish hysteria."
In all of the illustrations of this Reims Gospel, the Evangel-
ists "behave as though possessed with a demon of self-con-
sciousness: they are either furiously busy or gaze wildly
round; their clothes are crumpled and awry, as though to
signify their inner conflict and agony; and the landscape up-
heaves itself in sympathy."6

The distinct contributions of the south and of the
north can be recognized in art works from succeeding cen-
turies in spite of the fact that European civilization as a
whole experiences many common trends in the latter Medieval
period and the Renaissance. When circumstances affected all
of Europe, art flourished in those places where the times
encouraged native predilections; art diminished in importance
where circumstances did not coincide with the native sensi-
bility. The study of the history of art finds the south domi-
nating at some times, the north at other times. Italian art
inherited the Greek classic outlook;7 this attitude was espe-
cially appropriate at some dates and naturally found expres-
sion in plastic form. Germanic peoples inherited a less ra-
tional temperament that could be best expressed through non-
plastic form. Since that northern inclination was less com-

patible with the plastic, illusionistic, and classic stage in a
sequence, northern art flourished either when the times en-
couraged a planar, relatively abstract, and ritualistic style,
or when the times lent themselves to a painterly and emo-
tive style.

When one region prevailed, its style was exported
with varying results. Sometimes, the rest of Europe would
half-heartedly practice the style which dominated. Art in
such cases would almost seem reluctantly produced and was
looked on suspiciously by the public as imported goods. At
other times, after a time lag, the imported style took hold
and was modified to become the significant expression of
its adopted land. Particularly in the case of architecture,
the momentum of late antiquity carried Italy well into the
Medieval period. Italy had little reason to import early
Medieval northern architectural styles; most of the traffic
was from Italy to the north. Later, in the Gothic period,
a style of such vitality was developed in the north that it
could not be entirely ignored elsewhere. Although Gothic
architecture was not enthusiastically endorsed in Italy, there
was some traffic of style from north to south. Then, the
Renaissance style, an Italian product with echoes of antiquity,
superseded the Gothic. It was regarded for a long time by
the northerners as alien but it finally took hold firmly--the
major traffic flow was from south to north.

Taking the instance of basilican structures to con-
trast southern and northern buildings: first, a southern in-
vention, the northerners adopted the basilica plan and trans-
formed it into a valid expression of the northern Gothic
spirit; later, the Italians reasserted their claim to preemi-
nence in the design of basilicas; finally, the north caught up
with the Italian Renaissance modifications of the basilica.
In each period, as will be shown through examples below,
under southern influence the basilica remained consistent
with the Greek classic "ideal of beauty and serene repose";[8]
under the spell of the north the basilica was bewitched into
daring the fantastic and the staggering.

Looking for the ultimate source of the basilica plan,
one must go back to late antiquity (as was done to find the
prototype for the two Carolingian Evangelists). The Early
Christian basilica of the Constantinian fourth century in Rome
had been adapted from the multi-purpose assembly hall build-
ing of the Romans. The type of structure among Constan-
tinian churches that established the generic "basilica plan"

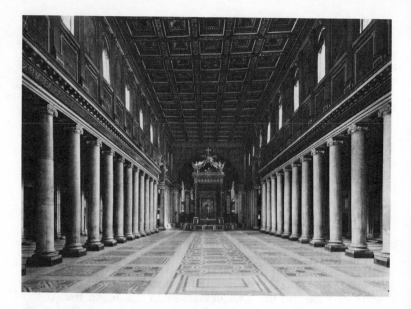

Figure 45. Sta. Maria Maggiore, Rome

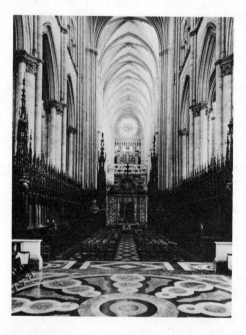

Figure 46. Amiens Cathedral

for later churches typically comprised a rectangular nave
with narrower side aisles on either side, main entrance at
one end (usually the west), apse at the opposite end (usually
the east), and, thus, a distinct longitudinal axis from en-
trance to apse. Originating, as it did, in the Mediterranean
region, the embellishment of the first church basilicas draws
upon the Greco-Roman architectural vocabulary. A fifth-
century Roman basilica, Sta. Maria Maggiore (Fig. 45), has
Ionic columns along the nave supporting a flat lintel; it has
a wooden coffered ceiling and a round triumphal arch fram-
ing the apse.

 The north adopted the basic basilica plan but over a
period of time the appearance of northern churches was
modified so greatly that the total effect of the northern off-
spring had little relation to the parent. In the twelfth to
fifteenth centuries, the transformation reaches its climax.
For example, in the thirteenth-century nave of Amiens ca-
thedral (Fig. 46) the compound pier has replaced the column
along the sides of the nave and, instead of supporting a flat
lintel, the piers support pointed arches. There is a vaulted
ceiling which is steeply arched, and the height of the crest
of the vault is unbroken; a view toward the apse would re-
veal that there is no framing arch separating the nave from
the apse. Most important for the striking change in the
total effect are the proportions of the nave of Amiens.
Whereas the nave of Sta. Maria Maggiore was a broad room,
that of Amiens is a steep canyon. The northerner preferred
a space unrelated to comfortably human dimensions, thus
encouraging an emotional rather than a rational experience.

 During the years between the construction of these
two buildings, while the north was developing increased
verticality, experimenting with vaulting and buttressing, and
substituting northern foliate ornament for such details as
Ionic capitals, Italy stayed true to the native tradition. The
twelfth-century façade of San Miniato al Monte (Fig. 47) and
the fifteenth-century façade by Alberti of Sta. Maria Novella
(Fig. 48) demonstrate the rational, human scale and the
persistence of Greco-Roman ornament in the embellishment
of the exterior of Florentine churches. They have engaged
columns, round arches, and pediments framing the nave

(Facing page): The interiors of two basilicas--demonstrating
southern characteristics in Italy versus northern characteristics
in France.

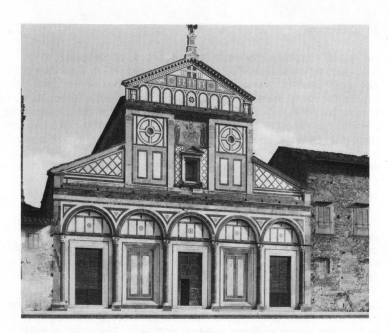

Figure 47. San Miniato al Monte, Florence

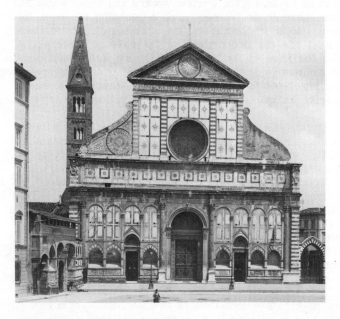

Figure 48. Sta. Maria Novella, Florence

roof. Intellectual contemplation is the appropriate means
for appreciating these rational Italian façades with their geo-
metric patterning on marble wall surfaces.

By way of contrast, the exteriors of two northern
churches under construction at the same times as these
Italian buildings assert the northern fascination with dizzying
height and the desire to overwhelm the spectator that were
already observed in the interior view of Amiens. St. Etienne
in Caen was begun in the latter part of the eleventh century
and was continued in the twelfth (Fig. 49). Ulm cathedral
was planned in the fifteenth century although finally completed
according to the plans as late as the nineteenth century (Fig.
50). Ulm, in its almost unbelievable intricacy of sculptural
ornament and the staggering height of its single spire, be-
longs to the emotive attitude. One is awed by the decoration
and is asked to believe that stone has no weight. One is
urged to let one's spirit soar upward, rising above the
northern gloom and doom, to heaven. "A critic who is prej-
udiced in favour of the classical may have no feeling for
this super-logical effect," but "anyone who has learned to
know the Gothic will to form... realizes the mighty world of
medieval sensibility, torn as it was by extremes and there-
fore capable of supernatural exertions of energy."[9]

The façade of Ulm may be described as the culmina-
tion of the Gothic sensibility, but there is a real question,
in the case of a contemporary Italian building, Sta. Maria
Novella, whether the label, Gothic, really applies. The
churchmen and architects responsible for Sta. Maria Novel-
la's design[10] were doubtless thinking back to earlier Italian
buildings like San Miniato, rather than looking to contempo-
rary Gothic buildings in the north. It would be instructive
for present purposes to observe a different Florentine build-
ing in which the architects were influenced by northern de-
velopments. For instance, the fourteenth-century nave of
the Florence cathedral (Fig. 51) is clearly an effort to make
a compromise between north and south.[11] It owes some
characteristics to the native Mediterranean tradition and
some to the most recent fashion of the north: Florence ca-
thedral may be compared with Sta. Maria Maggiore (Fig.
45) to see what it retains from the indigenous style, and
with Amiens Cathedral (Fig. 46) to see what it imports from

(Facing page): Two façades of Italian basilicas--one from
the 12th century and the other from the 15th century.

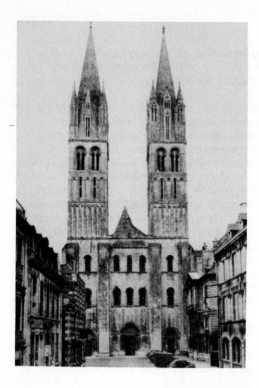

Figure 49. St. Etienne, Caen

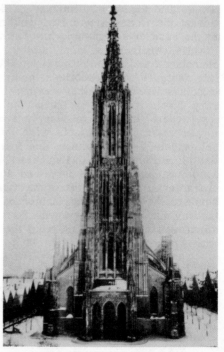

Figure 50. Ulm Cathedral

northern Gothic. Influenced by recent northern developments,
the Florence cathedral has composite piers marching along
the nave, and these piers support pointed arches. The nave
is roofed by a stone vault resembling the ribbed groined
vaults of the north. However, the broad, open feeling of
the Early Christian basilica has not been sacrificed since
the nave piers are widely spaced, and one can see into the
side aisles. Further, a vestige of the appearance of the
traditional triumphal arch frames the niche-like apse.

In fifteenth-century Italy, a deliberate rejection of the
northern influence and a conscientious return to the regional
predilection is fostered by Brunelleschi. In Santo Spirito,
Brunelleschi uses the column, the round arch, the flat,
coffered ceiling--all based on precedents of Greco-Roman
antiquity (Fig. 52). And the enthusiasm of the Italians for
their own Mediterranean tradition made it easy for Brunel-
leschi's followers to displace entirely the luke-warm Gothic-
ism of contemporary Italy. It was the turn of the northern-
ers to resist the spreading tide of Greco-Roman revival that
characterized Renaissance architecture.

The Gothic style was slow to give way in England
perhaps because the British were especially sympathetic with
the spirit of the Late Gothic idiom and were responsible for
a series of spectacular Late Gothic buildings. Among them,
several beautiful chapels were sponsored by royal patrons at
the end of the fifteenth century. A representative example
of this discussion (being a basilica) is St. George's Chapel,
Windsor, built by Henry VII and Henry VIII (Fig. 53). The
magnificent fan vault, done in the early sixteenth century,
exemplifies the science of vaulting pushed to its decorative
conclusion. With such vitality in the native tradition, no
wonder the English resisted the Italian Renaissance style.

Finally, in the seventeenth century, the Mediterranean
fashion reached even to England--brought largely through the
efforts of the British architect, Inigo Jones. The best-known
successor to Jones is Sir Christopher Wren. Returning to
the Greco-Roman architectural vocabulary as his basis, Wren
was clearly influenced by important recent buildings on the
continent that provided an updated version of the southern

(Facing page): Two façades of northern basilicas--one from
the 12th century and the other from the 15th century. These
should be contrasted with Figs. 47 and 48.

Figure 51. Flor-
ence Cathedral

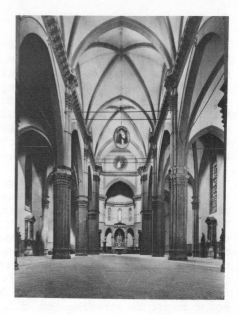

Figure 52. Brunel-
leschi: Santo Spirito,
Florence

predilection. Sixteenth-century Roman architecture (notably,
the dome of St. Peter's by Michelangelo) and seventeenth-
century Parisian buildings (notably, Perrault's east front of
the Louvre) helped formulate Wren's style. An example,
from among his many London churches, is St. Stephen,
Walbrook (Fig. 54). This interior is closer to Italian Ren-
aissance buildings (such as Santo Spirito, Fig. 52) than it is
to more recent British ones (such as St. George's Chapel,
Windsor, Fig. 53). Like many Italian Renaissance basilicas,
St. Stephen, Walbrook has Corinthian columns, round arches,
and a coffered ceiling. An unusual element is the dome over
the nave, a quite remarkable ingredient. The dome trans-
forms the nave from the usual, oblong rectangle into a sym-
metrical octagon. Instead of the predominant longitudinal
axis focusing one's attention on the apse, a rival vertical
axis diverts one's attention upward. The resulting general
impression is hardly that of a basilica at all, but of a cen-
tral-type building. It is pertinent that domed, central-type
buildings have been associated with the Mediterranean herit-
age ever since the Roman Pantheon.

 In spite of Sir Christopher Wren's enormous influence,
the Late Gothic northern style of Windsor's chapel never did
die out entirely in England. When the British Houses of
Parliament were rebuilt in the early nineteenth century, the
Gothic style was elected--with piers, steep gables, and
pointed arches. At the same date, however, work was un-
derway on the United States Capitol Building employing the
classical vocabulary of Greece and Rome--columns, pedi-
ments, and a dome. The significant point is that both
styles were considered suitable by Anglo-American cultures
at this date. (This comparison of two governmental build-
ings sets aside the self-imposed restriction to examples hav-
ing the basilica plan.)

 The succeeding Victorian decades saw--on both sides
of the Atlantic--Classic Revival buildings and Gothic Revival
buildings. Even into the twentieth century, the debt to
southern and northern European predilections is recognizable:
bank buildings, post offices, and New England village
churches were inclined toward the former; city churches
and college campuses were indebted to the latter. A facile
architect became skilled in both styles, and his clients often

(Facing page): Interiors of two Florentine basilicas--the 14th-
century one betrays northern influence, the 15th-century one
is insistently southern.

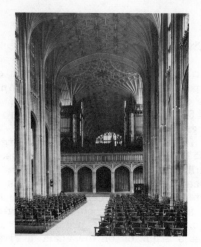

Figure 53.
St. George's
Chapel,
Windsor

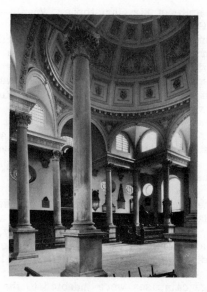

Figure 54.
Sir Christopher
Wren: St.
Stephen,
Walbrook

Interiors of two English basilicas--the 16th century one is to-
tally "northern," the 17th century one is completely "southern."

had little idea that the "either-or" decision they were asked
to make had such deep roots in European history. In later
buildings, both styles have sometimes become superficial
window-dressing rather than representing a commitment to
a basic, intrinsic meaning--and the twentieth century de-
velops a fresh, new architectural vocabulary with little debt
to the past.

The schism between the Mediterranean and the
northern persists into our own day in other guises. For
example, painters working in the eighteen-eighties and
eighteen-nineties founded two distinct avenues for modern
painting. Van Gogh, who was Dutch, and Carl Munch, who
was Norwegian, paved the way for Expressionism--a dis-
tinctly northern, emotive phenomenon. Seurat and Cezanne,
in keeping with the Latin heritage of Gaul, pointed toward
a modern art which places a premium upon rationality,
harmony, and order.

The year 1905 saw two groups of young artists
emerge as representatives of regional predilections.
Fauvism, in Paris, and The Bridge, started in Dresden,
had a common, flamboyant freedom in the handling of color.
However, Matisse, representing Fauvism, claimed that he
wanted his pictures to be as pleasant and relaxing as a
good armchair, whereas the ideal of Nolde, a member of
the Bridge, was "the intensive, often grotesque expression
of force and life in the simplest form."

In a few short years, both groups were affected by
the newest style development in Paris, Cubism, which was
less concerned with color and more, with composition.
The former Fauve, Georges Braque, a co-founder of Cubism,
especially fulfills the requirements for alignment with the
classic-rational Latin faction. His collage of a still life
(Fig. 55) has architectonic qualities that relate it to Greek
sculpture (Figs. 16, 17) and to paintings influenced by Greek
sculpture (Fig. 39). (Admittedly, the other founder of
Cubism, the Spaniard Picasso represents the fact that the
Iberian peninsula often displays an emotional temperament
contrary to the "Mediterranean" character of ancient Greece.)
Meantime the Bridge artists emphasized their German back-
ground by, among other things, taking up the woodcut me-
dium in the manner of Late Medieval German prints. The
woodcut by Schmidt-Rotluff (Fig. 56) has qualities of dis-
tortion and animation reminiscent of the Norse dragon head

Figure 55. Braque: Musical Forms

Figure 56. Schmidt-Rotluff: Way to Emmaus

(Fig. 40) and the Irish manuscript illumination of St. Luke
(Fig. 42).

Making a direct comparison of the Braque and the
Schmidt-Rotluff, executed in the same year (1918), one finds
considerable similarity in form. Both are angular, linear-
and-planar works--the predominant formal vocabulary at
this date fostered by Cubism--but there is a world of dif-
ference in subject matter and meaning. Braque chooses
inanimate objects; Schmidt-Rotluff chooses an emotional
scene with human figures. The choice of subject matter,
in each case, is typical of the style represented--Cubism
versus Expressionism. The subject helps determine the
difference in meaning--detachment versus involvement, the
classic versus the emotive. The essentially classic outlook
of Cubism that the Braque painting displays can be accounted
for, in part, by the persistent memory of the ideals of
Greece. On the other hand, the explanation for German
Expressionism includes the fact that regions outside the
orbit of ancient Greek culture developed a predilection lack-
ing her leavening influence.

(Facing page): Two paintings done the same year, 1918--
the French one is relatively "southern," the German one is
distinctly "northern."

Chapter VI

INVENTION

"The human situation admits invention only as a very
difficult tour de force"; so states George Kubler whose the-
ories underly this discussion of invention.[1] As was seen in
the last chapter, society "holds the course," so it is all but
impossible for the artist to make inventive changes. Not
only in ancient Egypt and medieval Byzantium, where con-
servatism was a conscious principle and a deliberate practice,
but throughout European history, there has been unconscious
resistance to new things because of the momentum of the
past.

Yet, invention takes place. Art never stays the
same--only the pace and direction of invention vary. As for
the pace of change, at one extreme there is the inadvertent
"drift" to a style in spite of the best intentions of artists
and their sponsors to produce "replications" of existing works.
Such a drift occurs even in Egyptian and Byzantine art. At
the opposite extreme, there is the accelerated change by in-
ventive artists who guide tradition.

This chapter will be especially concerned with the di-
rection accelerated change takes. The particular sort of
change permitted by society depends in large part upon tim-
ing. Some artists are lucky to make what Kubler calls a
"fortunate entrance"; the character of the change allowed in
their time coincides with their talents.

a. Innovation

One of the most favorable moments for the entrance
of the inventive artist occurs when there is a recognizable
need for new beginnings because old traditions are clearly
becoming outworn. Brunelleschi, Donatello, and Masaccio
could not have picked a better time or place to arrive on
the scene than early fifteenth-century Florence. Similarly,
European art had almost been waiting for Picasso and

Matisse in that state of suspension called the "fin de siècle" mood of the eighteen-nineties. At such times, society is less disapproving of change than usual. Inventive artists open welcome, new possibilities for exploration. Invention may start a linked succession of works that continues until unfolding possibilities are exhausted: such a development comprises a sequence. In the case of Masaccio (Figs. 6 & 62) and his contemporaries of the early fifteenth century in Florence, the resultant style was that of the Italian Renaissance. Picasso (Fig. 64), Matisse, and their friends created Cubism and Fauvism in the first decade of the twentieth century. For such sequence beginnings, often called the early stage, the term "innovation" is appropriate here.

The cases of the early fifteenth and the early twentieth centuries are especially clear-cut examples of the need for innovation, a need even recognized by contemporaries. Sometimes, the readiness for a new style may not be diagnosed at the time because it may not be apparent that old traditions are becoming exhausted. Further, the credit an innovator deserves is difficult to assess immediately. Only after the possibilities suggested by the artist have been explored is it clear how rich the new idea was and just where it led. Artistic innovation is the posing of a new problem rather than the solving of an old one. Today's hindsight confirms what some contemporaries of Masaccio and of the youthful Picasso realized, that these artists set forth the current artistic problem in such dramatic fashion as to articulate it for others. Put very simply, the problem posed by Masaccio for his generation and his successors was three-dimensional "space composition" (to use Berenson's term). The problem posed by Picasso for himself and his circle was two-dimensional, flattened composition. Usually, after some time has elapsed, the innovator receives acclaim, even where it was lacking at first; indeed, the acclaim overlooks the fact that part of the credit should be given to the accident of an entrance which permitted starting a sequence. In the cases of Masaccio and Picasso, their fame grew with the unfolding of the sequences they started.

b. Consolidation

After the first pioneers, the natural role for the inventive artist, who upon entry finds a new movement just started, is to help it along by further exploration. Then, the next arrivals on the scene will find the way smoothed and

will be able to consolidate--to organize and strengthen the
position recently attained. Pursuing the two initial examples
of Renaissance art and of modern art for the remainder of
this discussion, both provide specific cases.

After Masaccio--a prime innovator--had shown the
way in his Tribute Money (Fig. 6), others moved in and set-
tled the territory. Masaccio's program required the mastery
of anatomy and perspective for the realization of convincing
human figures inhabiting a believable spatial setting. Some
artists concentrated upon one or another aspect of the total
problem: for instance, Uccello studied perspective and
Pollaiuolo emphasized anatomy (Fig. 27).

Finally, at the end of the fifteenth century, the timing
was appropriate for real titans to wield with consummate
skill all of the means placed at their disposal by those who
preceded. It does not diminish the greatness of Raphael, for
example, to point out that the timing of his entrance allowed
him to draw upon what had gone before: Raphael's School of
Athens (Fig. 57) has a debt to Masaccio's Tribute Money.
[A similar relationship is observable between Michelangelo's
Expulsion in the Sistine Chapel (Fig. 68) and the Masaccio
Expulsion (Fig. 62).] While acknowledging the role of the
innovator, the rewarding opportunity afforded by this entrance
is the fulfillment of the potential of the sequence. For this
high stage of a sequence which is commonly called "classic,"
the term "consolidation" identifies the artistic process.

As for the modern world, in the fast pace of the
twentieth century the life cycles of Cubism and Fauvism were
accelerated fantastically. Taking Cubism as a demonstration
for the moment, after the original bold experiment of Picas-
so's Demoiselles d'Avignon (Fig. 64) and the subsequent in-
novations of Analytical Cubism by Picasso and Braque, it
was only a matter of months before people like Leger and
Duchamp were exploring, among other things, the potential
of Cubism to provide a symbolism for the machine age. The
prime innovator himself was still on the scene, however, to
contribute to the realization of the prospects of his own se-
quence. Picasso's Three Musicians (Fig. 59) may be con-
sidered as an example of the consolidation of Cubism.

Renaissance examples of innovation (see Fig. 6), consolida-
tion (Fig. 57, facing page), and expansive resolution (Fig.
58, facing page).

Figure 57. Raphael: <u>School of Athens</u>

Figure 58. Veronese: <u>Marriage at Cana</u>

c. Resolution--expansive, contractive

After a sequence's middle stage, artists arriving upon
the scene need not concern themselves with basics because
the structural mechanics of the current style have already
been explored. Those making their entrances late find their
range of opportunity severely curtailed. What is left for
them is either the expanding or the contracting of a sequence
that is no longer young. Depending upon their personalities,
they may embroider upon the style or they may reinterpret
the basic pattern; they may elaborate with new elements or
they may exhaust elements already present.

For an example of expansive resolution in the Renais-
sance, artists working in Venice often seemed to thrive upon
the license for embellishment and extravagance permitted by
the late timing of their entrances. Veronese's Marriage at
Cana (Fig. 58) is more sumptuous in color, more rich in
anecdotal detail, more vibrant with activity than Raphael's
School of Athens (Fig. 57). Tintoretto is another case of an
artist who seemed to relish the freedom that his late position
afforded (see Fig. 21).

On the other hand, Mannerist artists working in Flor-
ence and Rome often betrayed tense and introspective disposi-
tions and seemed to interpret their artistic roles differently.
Rosso Fiorentino (Fig. 71), Pontormo, and Bronzino restricted
themselves to the vocabulary of the High Renaissance as if the
style were a language to which new words might be introduced
only by combining old roots and stems. For one thing, these
Mannerists followed the pattern of High Renaissance artists
in employing sources from antiquity. However, they sought
different models, as if to exhaust all possibilities, and were
influenced, notably, by the model of late Roman sarcophagi
rather than by Classical Greece. Rosso Fiorentino's Deposi-
tion exhibits the "flattening of figures," "stress on diago-
nals," "agitated movement," and "lack of compositional focus"
that are among the points that Smyth lists as derived from
sarcophagi. [2]

Thus, two types of "resolution" occurred in the Ren-
aissance; one expansive, the other contractive.

Twentieth-century examples of innovation (see Fig. 64), con-
solidation (Fig. 59, facing page), and expansive resolution
(Fig. 60, facing page).

Figure 59. Picasso: Three Musicians

Figure 60. Picasso: Joy of Life

As for the twentieth century, Cubism also reflects a divergence in the final phases. The innovator himself, Picasso, still very much a principal in the story, seemed to consider his own style as a potential ingredient for various purposes. Expansive ease in applying Cubism is demonstrated by his Joy of Life (Fig. 60), done in 1946 long after the urgency of the style's innovation (the Demoiselles d'Avignon was painted in 1907) and consolidation (the Three Musicians (Fig. 59), in 1921). Contrarily, many Cubist followers seemed more rigorous in the single-minded pursuit of a non-objective conclusion for Cubism. As examples, Mondrian restricted himself to pure verticals, horizontals, and primary colors; Ozenfant and Le Corbusier even named their simple geometry Purism.

Of the two sorts of resolution that a sequence experiences, the first type might be called ebullient--a style concludes by bubbling over, and the overflow becomes the source for something new. Thus, Veronese and Tintoretto are frequently called Proto-Baroque. Specifically, rather than considering Veronese's Marriage at Cana (Fig. 58) as the culmination of what started with Masaccio's Tribute Money (Fig. 6) and led to Raphael's School of Athens (Fig. 57), the Veronese painting may be thought of as the beginning of a new sequence that leads to Rubens. Similarly, many of Picasso's later Cubist-related works might be claimed by Surrealism or Expressionism. In our example, the Joy of Life (Fig. 60), Cubism is no longer separate but enriches and is enriched by Fauvism. (See page 135.) It might be appropriate to coin the term, Fauve-Cubism, for this painting and for many others in the second quarter of the twentieth century that require such an expanded classification. Pertinent here is Henri Focillon's description of a style's "defining itself and then escaping from its own definition."[3]

The second sort of resolution is metaphorically a case of boiling down--a sequence concludes by turning inward, becoming more intense and more restricted. Focillon also has a description for this kind of cycle: a style evolves by "testing itself, building itself, and annihilating itself."[4] Perhaps because they felt intimidated by the past, Mannerist artists often appeared to be intent on reacting against those ideals of serenity, harmony, and balance of the High Renaissance.[5] Such a case is demonstrated by Rosso Fiorentino's Deposition (Fig. 72). Naturally, when especially concerned with negating the past, Mannerism did not suggest prospects for future development. (Rather than an outgrowth of Mannerism, the early Baroque emerged as anti-Mannerism.)

Similarly, Mondrian's definitive purification of Cubism or Malevich's "suprematism" seemed to leave little for followers to pursue. (After a time, Albers and others <u>did</u> find a path to follow in the pursuit of geometric purity.)

d. Confluence

The preceding outline of the most likely opportunities for invention afforded by different entrances is clearly an oversimplification. First, it assumes that there is a predominant tradition into which the artist is inserted. But, of course, at any date in history there are rival contemporary styles and sequences at different stages of development. This makes the entrant's position somewhat less easy for himself to sense and far less easy for the historian to plot. As Kubler puts it, "The perpetual problem confronting the historian has always been to find the beginning and the end of the threads of happening."[6]

To consider the problems of what Ackerman calls "confluent, overlapping, and interacting styles,"[7] first, the matter of overlapping endings and beginnings. There is always the possibility of two currently practiced sequences-- one artist working in the last stages of an old one, the other in the first stage of a new one. A pertinent instance, at the beginning of the fifteenth century occurs when Medieval traditions persisted alongside of Renaissance ones. The Limbourg brothers' Expulsion (Fig. 61) from the Très Riches Heures of the Duc de Berry belongs to the old order, the manuscript tradition, as compared with the contemporary Early Renaissance fresco of the same subject by Masaccio from the Brancacci Chapel (Fig. 62). What a contrast there is between the Limbourgs' decorative Adam and Eve being expelled (the right-hand episode) and the dramatic immediacy of Masaccio's Expulsion!

The Limbourg brothers were sometimes more progressive than in the Expulsion scene. Other manuscript pages by them testify that they were experimenting with visually realistic landscapes, one hallmark of the beginning of the Renaissance. In this same page, the kneeling Adam (being tempted on the left) is similar to the Isaac of Brunelleschi's famous "competition panel," recently a controversial work-- the pose may be based ultimately on an ancient source, suggesting that the Limbourgs were interested in current Renaissance developments in rendering the human figure. Yet,

(cont. on p. 133)

Figure 61. Limbourg brothers: Fall of Man and Expulsion
from Paradise from the Très Riches Heures

Figure 62. Masaccio: <u>Expulsion from Paradise</u>

Figure 63. Renoir: Nude Girl Reclining

Figure 64. Picasso: Demoiselles d'Avignon

the illumination deserves to be called Late Medieval, rather than Early Renaissance, because of the basically conservative attitude toward painting as an ornament and symbol rather than a reproduction of a natural scene.

The example of the Limbourgs versus Masaccio brings in regional predilections, northern versus Mediterranean, as well as providing an instance of simultaneous endings and beginnings of styles. Masaccio's partner in the Brancacci Chapel, Masolino, was conservative despite his contact with Masaccio and the progressive Florentine environment. Masolino did a Temptation of Adam and Eve that represents the Late Medieval as fully as do the Limbourg figures. This Temptation is located across from Masaccio's Expulsion providing a contrast of styles explainable as the old versus the new orders.

Another example of overlapping beginnings and endings of sequences occurs while Picasso was forging a radical, new style soon to be called Cubism with his Demoiselles d'Avignon (Fig. 64). Simultaneously, Renoir was painting in final augmentation of the Impressionist style in works such as his Nude Girl Reclining (Fig. 63). Although they are contemporary, the paintings have what Kubler calls "different systematic ages."[8]

Now considering the problem of contemporary confluent sequences, it has been mentioned that Picasso and Matisse, both innovators, arrived on the Paris art scene at almost the same time. Each being a dominating personality, they launched separate new styles, Cubism and Fauvism. Although these sequences eventually interacted upon one another, at first in large part they were opposites. Fauvism employed bright colors; Cubism restricted its palette. In Fauvism, curves predominated; in Cubism, rectilinear shapes prevailed. Fauvism is emotional, Cubism rational.

Briefly, it is relevant to take notice of the separate early Fauve development. Fauvism actually preceded Cubism by a few years and its rate of change was, if anything, faster than the pace of Cubism. The beginnings of Fauvism in 1903 and 1904 exhibit a spotty brushwork whose source is Impressionism. Shortly, another phase, represented by

(Facing page): Twentieth-century examples of overlapping endings and beginnings of styles. Picasso picture from Collection, the Museum of Modern Art, New York, acquired through the Lillie P. Bliss Bequest.

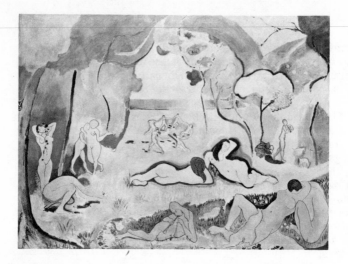

Figure 65. Matisse: <u>Joy of Life</u> (copyright 1974 The Barnes Foundation)

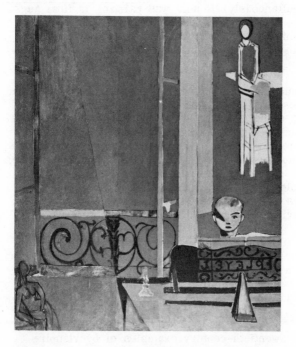

Figure 66. Matisse: <u>Piano Lesson</u> (Collection, The Museum of Modern Art, New York, Mrs. Simon Guggenheim Fund)

Matisse's Joy of Life of 1905-6 (Fig. 65), has a smoother brushwork more analogous with Gauguin. Although the evolution of Fauvism is sporadic rather than even-paced, one could defend the position that this Matisse may be credited with being an example of the "consolidation" of Fauvism; it has the assured mastery of the style's vocabulary that deserves that label. (Note, this painting predates the Picasso Joy of Life by forty years.)

In the later stages of Fauvism and Cubism, the two confluent sequences became susceptible to influence from one another. Specifically, retaining the bright palette of Fauvism, Matisse turned to an angular construction--like that of Cubism --in works such as the Piano Lesson of 1916-17 (Fig. 66). As can be readily seen, Picasso, working from the opposite direction when painting his version of a Joy of Life in 1946 (Fig. 60), was using Fauve-like curvilinear shapes. These two paintings represent the ebullient stages of their respective sequences; each could almost serve as a representative of the rival style.

Indeed, there is a real question whether the cited later paintings of Matisse and Picasso really do belong to the same sequence as the examples of the artists' prior works, whether they belong to the rival sequence, to an enlarged category (Fauve-Cubism?), or to another classification entirely. One can take the position that Fauvism had burned itself out by the mid-teens and that every artist involved with the movement, including Matisse, had been forced to attach himself to another sequence or to start a new one; yet Matisse's later painting does have a family relationship to his earlier one. In Picasso's case, his style had certainly undergone many transformations between the mid-point of the Three Musicians (Fig. 59) and the tardy date of his version of the Joy of Life (Fig. 60); but in spite of many intermediate pursuits, one way of classifying the later work is to consider it as a witty elaboration of the planar vocabulary of the earlier one. Going back to the beginning of Cubism, one can also compare the harsh Demoiselles d'Avignon with the late, effervescent Joy of Life and conclude that the two are the beginning and end of the same sequence. Of course,

(Facing page): Examples of parallel confluent styles. Compare the consolidation and resolution of Fauvism (illustrated here) with the consolidation and resolution of Cubism (Figs. 59 & 60).

the best answer to the problem of the resolution of confluent
traditions in the twentieth century is simply that the "threads
of happening" become intertwined.

These problems of "confluent, overlapping, and inter-
acting styles"[9] make the old biological metaphor of "evolu-
tion" of limited use. Kubler has proposed an alternative to
all of the familiar cyclical images. "Instead, we can imag-
ine the flow of time as assuming the shapes of fibrous bun-
dles, with each fiber corresponding to the need upon a par-
ticular theater of action, and the lengths of the fibers vary-
ing as to the duration of each need and the solutions to its
problem. The cultural bundles therefore consist of variegat-
ed fibrous lengths of happening, mostly long and many brief.
They are juxtaposed largely by chance, and rarely by con-
scious forethought or rigorous planning."[10]

e. Deflection

To pursue this image of a sequence as a fiber in a
cultural bundle, one needs to take into account the possibility
of an artist's rejection of the natural role that his entrance
provides for him. What if an artist, who is by temperament
best-suited as an innovator, is unlucky enough to be born
into a well-defined tradition which has already passed the
stage of innovation? If the artist insists on innovation, nev-
ertheless, one of two things may happen. He may start a
second, rival sequence whose ultimate span may be as long
as that of the concurrent one. Or his innovation may only
momentarily intrude, being a minor deflection from the main
course--as it were, a nodule on the main fiber that failed to
become a separate stalk. Another kind of deflection occurs
when an artist, who is inclined toward either consolidation
or elaboration, picks up an aborted bud or a seemingly ex-
hausted fiber and revives it. Thus, no sequence is ever re-
ally dead, only dormant.

At the time, no one can tell whether an aberration
will become a major style or remain simply a deflection.
Even later, scholars may have difficulty deciding as to the
proper definition of a given sequence of works. It used to
be generally considered that Mannerism was a deflection
rather than one of the major, logical consequences of Ren-
aissance development. The question of the position given
to Mannerism depends, in part, on the place one cuts the
"thread of happening." For some purposes, the Baroque

period can be considered to be the late stage of the Renais-
sance--with this broad view, Mannerism diminishes in im-
portance. But if the Baroque is considered to be another,
separate fiber, then Mannerism is granted a more significant
role. Then, it is one finale for the Renaissance, the reduc-
tive one--just as Mondrian is one reduction to undiluted es-
sentials of Cubism.

Perhaps a better example of deflection in the Renais-
sance is the case of the neo-Gothic style. In the middle of
the fifteenth century, certain Italian artists who were seem-
ingly totally absorbed in furthering the goals of Masaccio
suddenly deflected from the course. Such an artist was
Castagno whose David (Fig. 67) seems closer to the Medie-
val concept of a picture as an ornament, like the Limbourg
Paradise and Expulsion (Fig. 61), than to the Renaissance
concept of a picture as a duplication of three-dimensional
reality. To paraphrase Panofsky, the Medieval talent for
surface decoration was dying "of an overdose of perspective,"
and Castagno was, in this painting, expressing regret at its
passing. Specifically, the figure of David is flattened, rather
than being properly foreshortened; the clouds refuse to stay
in the distance and become surface pattern; and, instead of
broad, plastic folds, the fluttering drapery provides linear
enrichment. However, it is clear that this phenomenon is
simply a deflection, rather than a separate fiber, because
soon Michelangelo is squarely back on the course set by
Masaccio in his Expulsion (Fig. 68).

Another example that may be considered deflection in
the fifteenth century is the portrait of Montefeltro in profile
by Piero della Francesca (Fig. 34). Like the conservatism
of Castagno's David, a profile portrait is a kind of belated
statement of a fourteenth or early fifteenth-century late
Gothic type. In this case, Piero's reasons for selecting a
profile view are bound up with the formality afforded by the
linear-and-planar silhouette (and with expediency since Monte-
feltro had lost his right eye in a duel). However, explana-
tions should not be construed as apologies. The concept of
deflection simply recognizes that there is no iron-clad fatal-
ism in the course a sequence takes, neither in its pace nor
in its direction.

Turning to the twentieth century, recent art history
has been peppered with deflection of another sort, innovation,
because everyone wants to be "original." Modern society
seems to operate under the assumption that change deserves

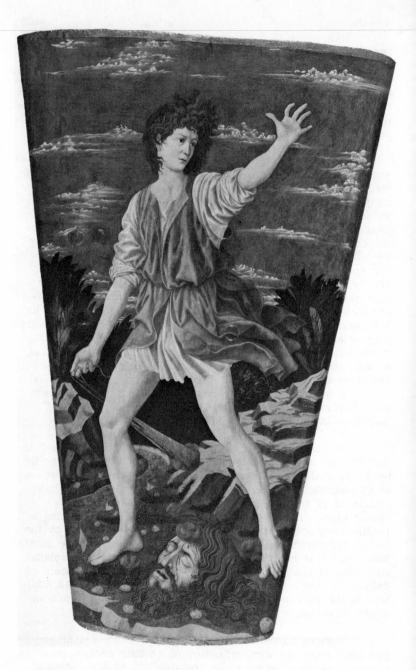

Figure 67. Castagno: <u>David</u>

On the left, an example of deflection in the Renaissance to contrast with Fig. 62. Below, an example of the subsequent development of the main fiber of the Renaissance.

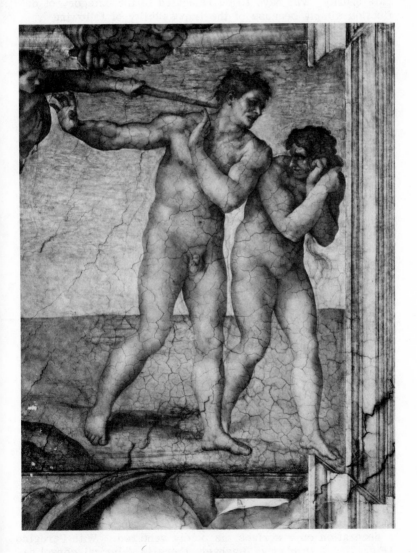

Figure 68. Michelangelo: Expulsion

praise simply because it is change. Today, it is hard to
imagine the frame of mind of the Egyptian or Byzantine artist
who tried to conform as much as possible to rigid formula.
To us, an artist is, by definition, a creator--not a perform-
er. (We forget that all musicians are not composers.) Ob-
viously, the majority of today's creation, even that of first-
rate quality, will have to be relegated to the category of de-
flection simply because of the impossibility of following
through on the potentials of such an enormous output of in-
novation.

f. Conclusion

 This discussion of invention has mainly concerned the
direction, rather than the pace, of change; there seems to be
little regularity to the pace except for some very general hy-
potheses. In predicting the future, it is fairly safe to as-
sume that in modern society invention will continue to occur
with dizzying rapidity, and urban settings will move faster
than provincial locations. [11] However, in spite of the snow-
balling of events, some constant factors will tend to retard
acceleration. One constant is the life span of an artist: the
timing of his working life will be the same as always: a
student phase, youthful adulthood, maturity, and old age. [12]
Curiously, another retarding factor is the role of art as
communication. If a sequence moves too fast, the observer
fails to understand the meaning expressed. Kubler notes a
parallel between art and language, finding evidence for a re-
tarding of change in art because of the relationship. He
maintains, "The rate of change in language is regular be-
cause communication fails if the instrument itself varies er-
ratically...works of art resemble a system of symbolic com-
munication...the history of art may eventually prove to con-
tain unexpected potentials as a predictive science."[13]

 To review the discussion of the direction of change,
one may consider a sequence of Italian paintings of the oft-
treated theme of the Crucifixion. The series begins with
Cimabue (Fig. 69), when the stylized Byzantine formulas,
however impressive, were becoming outworn. In a remark-
able instance of metamorphosis, this late Medieval style be-
comes the Proto-Renaissance. Next, there is the deliberate
innovation of Masaccio's painting (Fig. 70) in which the idea
of a picture as a prospect through an opening, rather than
a decoration on a surface, is boldly ventured. With Perugino
(Fig. 71), a teacher of Raphael, there is a lyrical consolida-
tion for the series. This version of the subject displays the

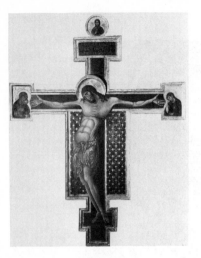

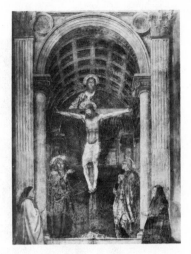

Figure 69.
Cimabue:
Crucifixion

Figure 70.
Masaccio:
Crucifixion

Figure 71. Perugino: Crucifixion

Figure 72:
Rosso:
Deposition

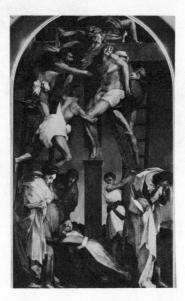

Figure 73
(below).
Veronese:
Calvary

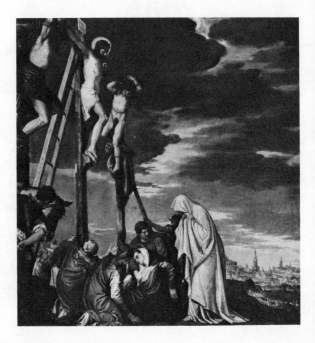

Examples (Figs. 69-74) that review
the major theses of this book.

Figure 74. Grunewald: Crucifixion from the
Isenheim Altarpiece

balanced composition and the serenity of mood that epitomizes
this mid-position in the Renaissance. Then, with the work
of Rosso Fiorentino (Fig. 72) and Veronese (Fig. 73), the
forking of the main fiber at the later stages becomes appar-
ent. As in the earlier paintings, Rosso places the Cross
parallel to the picture plane, and his plastic form is like
prior Renaissance compositions; yet, he seems intent on dis-
rupting the earlier serenity of mood by creating imbalance
with sharp, zig-zag gestures. On the other hand, Veronese
exploits a more fluid motion in the figures; he turns the
Cross at a recessional angle; and he employs exceedingly
dramatic light and color. While Rosso's painting is a back-
ward-looking finale, Veronese is taking the anticipatory role
played by Cimabue: he is Proto-Baroque.

Additionally, one may observe that this series of
paintings reviews the major theses of the earlier chapters of
this book: the sequence moves from the linear-and-planar,
to the linear-and-plastic, to the painterly. It moves from
a style of essence to a more illusionistic style. It moves
from the ritualistic attitude through the various stages of the
aesthetic attitude. To complete this retrospective survey of
the volume's chapters, one final illustration is necessary.
It remains to compare these Italian Renaissance paintings
with a northern one in order to observe regional predilections.
The German, Grünewald, a contemporary of Perugino, painted
a Crucifixion (Fig. 74) which provides a good example because
the painting emphasizes the horror of the event. Containing
only an incidental hint of redemption (the bleeding lamb),[14]
Grunewald depicts an anguished, nightmare world, while
Perugino's version expresses confidence in salvation by the
day-lit serenity of the whole scene.

Obviously, such patterns for style and sequence are
not always clear in art, but this essay has been dedicated to
a notion voiced by Ackerman: The fact that a "pattern can-
not be found in every sequence... does not lessen our re-
sponsibility to explain it where it can be found."[15]

NOTES

Preface

1 Erwin Panofsky, "Wilhelm Voge: A Biographical Memoir," Art Journal, Fall, 1968, p. 28.

Chapter I, STYLE AND SEQUENCE

1 See H. W. Janson, History of Art. Englewood Cliffs: Prentice-Hall, 1966, "Introduction," especially p. 11-12.

2 George Kubler, "Style and the Representation of Historical Time," Annals, New York Academy of Sciences, Vol. 138, 1967, p. 854.

3 Ibid., p. 854-855.

4 Heinrich Wölfflin, Principles of Art History. New York: Dover Publications, 1932 etc., p. 230. (Originally published in German in 1915.)

5 E. H. Gombrich, Art and Illusion. New York: Pantheon, 1960, p. 315; and also "Truth and Stereotype," Ch. II, "The Analysis of Vision in Art," Ch. IX.

Chapter II, FORM

1 Leon Battista Alberti, "De Pittura," A Documentary History of Art, ed. Elizabeth Holt. Garden City: Doubleday, 1957, p. 211.

2 Wölfflin, Principles of Art History, p. 18.

3 This is E. H. Gombrich's suggestion from his criticisms of the Wölfflinian approach in Norm and Form. London: Phaidon, 1966, p. 93-94.

4 Alberti presented the idea of an imaginary "visual pyra-
 mid" tilted on its side. The apex is the eye of the
 observer; the base is the object observed; and the
 sides are the lines of sight from the eye to the object.
 The picture plane--between the eye and the object--
 transects the pyramid; thus, the object seen becomes
 projected in reduced scale upon the picture plane.
 Alberti, op. cit., p. 209. See John White, The Birth
 and Rebirth of Pictorial Space (London: Faber and
 Faber, 1957) for further discussion of Brunelleschi
 and Alberti regarding perspective.

5 Wölfflin, Principles, p. 18-19.

6 Bruno Zevi, Architecture as Space. New York: Horizon
 Press, 1957.

7 See Lionelli Venturi, Painting and Painters. New York:
 Charles Scribner's Sons, 1945, p. 19 and 24.

8 Giorgio Vasari, Lives of the Most Eminent Painters,
 Sculptors, and Architects, tr. by Gaston du Vere.
 London: Macmillan, vol. 1, p. 63 and 67.

9 David M. Robb and J.J. Garrison, Art in the Western
 World. New York: Harper and Row, 1963, p. 515.

10 Sir Joshua Reynolds, Discourses on Art. New York:
 Collier Books, 1961, p. 60-64. (Discourses original-
 ly delivered to the Royal Academy between 1769 and
 1790.)

11 Gombrich, Norm and Form, p. 82.

12 James Ackerman, "Style," Art and Archaeology, Acker-
 man and Rhys Carpenter. Englewood Cliffs: Prent-
 ice-Hall, 1963, p. 172. (First published as "A
 Theory of Style," Journal of Aesthetics and Art Crit-
 icism, Spring, 1962.)

13 Gombrich, Norm and Form. This is the major thesis
 of the title chapter.

14 Ackerman, "Style," p. 172.

15 Bernard Berenson, Italian Painters of the Renaissance.
 New York: Meridian Books, Inc., 1957, p. 329-330.

(Four essays originally published between 1894 and 1907.)

16 Alois Riegl, Spätrömische Kunstindustrie. Darmstadt: Wissenschaftliche Buchgesellschaft, 1964.

17 Gombrich, Art and Illusion, p. 19.

18 Wölfflin, Principles, p. 14.

19 Ibid, p. 14.

20 Gombrich, Norm and Form, p. 97.

21 Paul Frankl, Das System der Kunstwissenschaft. R.M. Rohrer, 1938. Curt Sachs, The Commonwealth of Art. New York: W.W. Norton, 1946, p. 199. Lincoln Rothschild, Style in Art. New York: Thomas Yoseloff, 1960.

22 Sir Herbert Read, The Meaning of Art. Baltimore: Penguin, 1963, p. 21.

23 Ibid, p. 50.

24 Gombrich, Art and Illusion, p. 24.

25 Meyer Schapiro, "The Liberating Quality of Avant-Garde Art," Art News, Summer, 1957, unnumbered.

26 Ibid, unnumbered.

27 Gombrich, Norm and Form, p. 97.

28 George Kubler, The Shape of Time. New Haven: Yale University Press, 1962, p. viii.

29 Ibid., p. 33.

30 Ibid., p. 55-56.

31 John Adkins Richardson and John I. Ades, "D.H. Lawrence on Cezanne: A Study in the Psychology of Critical Intuition," Journal of Aesthetics and Art Criticism, Summer, 1970.

32 Thomas Munro, Form and Style in the Arts. Cleveland: Case Western Reserve Press, 1970, p. 252.

Chapter III, SUBJECT

1 Wilhelm Worringer, Abstraction and Empathy. Cleve-
 land: World, 1967. (Originally published in German
 in 1908.)

2 See footnote I, 3.

3 See Gombrich, "From Light into Paint," Art and Illu-
 sion, Ch. I.

4 Gombrich, "The Beholder's Share," Art and Illusion,
 Part III.

5 See Emmanuel Loewy, The Rendering of Nature in Early
 Greek Art. London: Duckworth, 1907, p. 10-18.
 (First published in German in 1900.)

6 Ibid., p. 18-19.

7 Gombrich, Art and Illusion, p. 23 and footnote, p. 403.

8 Gombrich, Meditations on a Hobby Horse. London:
 Phaidon, 1963, p. 4.

9 Also, see Gombrich, Art and Illusion, p. 202.

10 This is the title of a book by Worringer; see footnote
 III, 1.

11 Theodor Lipps, Ästhetik. Hamburg and Leipzig: Verlag
 von Leopold Voss, 1903 and 1906, vol. 2, p. 1.

12 Sir Herbert Read, The Meaning of Art. Baltimore:
 Penguin, 1965, p. 30. (First published in 1931.)

13 Worringer, Abstraction and Empathy, p. 15.

14 Ibid., p. 15.

15 Read, op. cit., p. 19.

16 Sir Herbert Read, Icon and Idea. New York: Schocken
 Books, 1965, p. 42. (First published in 1955.)

17 Worringer, Abstraction and Empathy, p. 15.

18 Read, Icon and Idea, p. 38.

19 Gombrich, Art and Illusion, p. 93 and 116.

20 Ibid., p. 107.

21 Ibid., p. 112.

22 Ibid., p. 109.

23 Ibid., "Reflections on the Greek Revolution," Ch. IV.

24 Ibid., Ch. IV.

25 Gombrich, Meditations, p. 9.

26 Gombrich, Art and Illusion, p. 144.

27 Meyer Schapiro, "Nature of Abstract Art," Marxist
 Quarterly, Jan.-March, 1937, p. 86.

28 Gombrich, Meditations, p. 41.

29 Harold Rosenberg, The Anxious Object: Art Today and
 Its Audience. New York: The Horizon Press, 1964,
 p. 17-18.

30 See Rosenberg, op. cit., "The Continuing Current,"
 Part 6.

Chapter IV, MEANING

1 Alois Riegl, Stilfragen. Berlin: Schmidt, 1923, p. vii.
 (First published in 1893.)

2 Worringer, Abstraction and Empathy, p. 9-10.

3 Erwin Panofsky, Meaning in the Visual Arts. Garden
 City: Doubleday, 1955, p. 14. (This chapter was
 first published in 1940.)

4 Gombrich, Meditations, p. 35.

5 Ibid., p. 35-36.

6 Barbara Novak, American Painting in the Nineteenth
 Century. New York: Praeger, 1969, p. 15.

7 See page 75 for more complete quotation.

8 See page 55.

9 Creighton Gilbert, "New Evidence for the Date of Piero
 della Francesca's Count and Countess of Urbino,"
 Marsyas, 1941, p. 41-57.

10 S. J. Freedberg, Painting of the High Renaissance in
 Rome and Florence. Cambridge: Harvard University
 Press, 1961, p. 14.

11 Ibid., p. 15.

12 See Barbara Novak, op. cit., Chs. 5 and 6.

13 Freedberg, op. cit., p. 130.

14 Ibid., p. 130.

15 The "Classical" will be capitalized when the word is
 used as a proper noun for an historical period (mean-
 ing particularly the latter half of the fifth century
 B.C. in Greece). Lower case will be used for the
 more generic senses of the word, classic.

16 For further discussion of proportion, see Panofsky,
 "The History of the Theory of Human Proportions as
 a Reflection of the History of Styles," Meaning in the
 Visual Arts. (This chapter was first published in
 1921.)

17 Edith Hamilton, The Greek Way. New York: Mentor,
 1960, p. 209. (First published in 1930.)

18 Sir Herbert Read, Icon and Idea, p. 70.

19 Freedberg, op. cit., p. 574.

20 See page 75 for more complete quotation.

21 Gombrich, Meditations, p. 36.

22 See footnote II, 21.

23 Curt Sachs, The Commonwealth of Art. Washington:
 U.S. Printing Off., 1950, p. 9.

24 Ibid., p. 18.

25 Ibid., p. 15-17.

26 Schapiro speaks of the "abstract devices in Renaissance
 art, especially the systems of perspective and the
 canons of proportion, which are today misunderstood
 as merely imitative means...the artists strove to
 realize in their own imaginative field, even within
 the limits of traditional religious content, the most
 appropriate and stimulating forms of spatial order."
 "Nature of Abstract Art," p. 88.

Chapter V, PREDILECTION

1 This chapter is concerned with a topic so basic that it
 can hardly be completely avoided by art historians
 writing on European style development. Behind all
 recent discussions of the subject is the pioneering
 work, Wilhelm Worringer's, Form in Gothic (New
 York: Schocken, 1964). (First published in German
 in 1910.) For a discussion of national, rather than
 regional, predilections, see Sachs, "Dominance of
 Individual Nations," The Commonwealth of Art, p. 373-
 389.

2 Kubler, The Shape of Time, p. 68.

3 Ackerman, "Style," p. 176.

4 Worringer, Form in Gothic, p. 166.

5 Sachs, The Commonwealth of Art, p. 218.

6 Roger Hinks, Carolingian Art. Ann Arbor: University
 of Michigan Press, 1963, p. 140. (First published in
 1935.)

7 Wölfflin stressed that the Italian Renaissance affinity for
 classic art is a "national feature"; it is a "completely
 spontaneous expression...not an imitation of a foreign
 prototype." Wölfflin, Classic Art. New York:
 Phaidon, 1961, p. xvi. (Originally published in Ger-
 man in 1898.)

8 Worringer, Form in Gothic, p. 166.

9 Ibid., p. 166.

10 Sta. Maria Novella dates from the fourteenth century;
 Alberti's façade was added in the mid-fifteenth cen-
 tury.

11 Although for the purposes of the present discussion, it
 is appropriate to observe a Florentine Gothic build-
 ing, the cathedral of Milan is the most strikingly
 northern-looking cathedral in Italy.

 Chapter VI, INVENTION

1 Kubler, The Shape of Time, p. 68. This chapter uses
 Kubler's volume as a base, and many of the ideas
 and choices of words are based upon his essay.

2 Craig Hugh Smyth, Mannerism and Maniera. Locust
 Valley: J. J. Augustin, 1962, p. 14. (Smyth, in
 turn, acknowledges a debt to Riegl, Spätrömische
 Kunstindustrie.)

3 Henri Focillon, The Life of Forms in Art. New York:
 Wittenborn, 1948, p. 8. (First published in French
 in 1934.)

4 Ibid., p. 7.

5 Friedlaender first presented the interpretation of Man-
 nerism as an "anticlassical" style in 1914. Walter
 Friedlaender, Mannerism and Anti-Mannerism. New
 York: Schocken, 1965, p. xi. (First published in
 1925.)

6 Kubler, op. cit., p. 78.

7 Ackerman, "Style," p. 185.

8 Kubler, op. cit., p. 56.

9 Ackerman, op. cit., p. 185.

10 Kubler, op. cit., p. 122.

11 Ibid., p. 93.

12 Ibid., p. 102.

13 Ibid., p. 61.

14 The symbol of a bleeding lamb is a sign that the physi-
 cal torture has spiritual implications.

15 Ackerman, op. cit., p. 177-178.

LIST OF ILLUSTRATIONS

Captions and Credits

Page

BIBLIOGRAPHY

Ackerman, James, "Style," Art and Archaeology, by Acker-
 man and Rhys Carpenter. Englewood Cliffs: Prentice-
 Hall, 1963. (First published as "A Theory of Style,"
 Journal of Aesthetics and Art Criticism, Spring, 1962.

Berenson, Bernard, Italian Painters of the Renaissance. New
 York: Meridian Books, Inc., 1957. (Four essays
 originally published between 1894 and 1907.)

Focillon, Henri, The Life of Forms in Art. New York:
 Wittenborn, 1948. (Originally published in French in
 1934.)

Frankl, Paul, Das System der Kunstwissenschaft. R. M.
 Rohrer, 1938.

Freedberg, S. J., Painting of the High Renaissance in Rome
 and Florence. Cambridge: Harvard University Press,
 1961.

Friedlaender, Walter, Mannerism and Anti-Mannerism. New
 York: Schocken, 1965. (First published in German in
 1925.)

Gilbert, Creighton, "New Evidence for the Date of Piero
 della Francesca's Count and Countess of Urbino,"
 Marsyas, 1941.

Gombrich, E. H., Art and Illusion. New York: Pantheon,
 1960. (Originally delivered as the A. W. Mellon Lec-
 tures in the Fine Arts in 1956 at the National Gallery,
 Washington, D. C.)

_____. Meditations on a Hobby Horse. London: Phaidon,
 1963.

_____. Norm and Form, Studies in the Art of the Ren-
 aissance. London: Phaidon, 1966.

_____. The Story of Art. London: Phaidon, 1960.

Hamilton, Edith, The Greek Way. New York: Mentor,
 1960. (First published in 1930.)

Hinks, Roger, Carolingian Art. Ann Arbor: University of
 Michigan Press, 1962. (First published in 1935.)

Holt, Elizabeth G., ed., Literary Sources of Art History.
 Garden City: Doubleday, 1957.

Janson, H. W., History of Art. Englewood Cliffs: Prentice-
 Hall, 1966.

Kleinbauer, W. Eugene, Modern Perspectives in Western Art
 History. New York: Holt, Rinehart, and Winston,
 1971.

Kubler, George, The Shape of Time. New Haven: Yale Uni-
 versity Press, 1962.

_____. "Style and the Representation of Historical Time,"
 Annals, New York Academy of Sciences, Vol. 138,
 1967.

Lipps, Theodor, Ästhetik. Hamburg and Leipzig: Verlag
 von Leopold Voss, 1903 & 1906, 2 vols.

Loewy, Emmanuel, The Rendering of Nature in Early Greek
 Art. London: Duckworth & Co., 1907. (Originally
 published in German in 1900.)

Miles, Josephine, "Toward a Theory of Style and Change,"
 Journal of Aesthetics and Art Criticism, Fall, 1963.

Munro, Thomas, "Do the Arts Evolve, some Recent Con-
 flicting Answers," Journal of Aesthetics and Art Criti-
 cism, Summer, 1961.

_____. Form and Style in the Arts. Cleveland: Case
 Western Reserve Press, 1970.

_____. "Recent Developments in Aesthetics in America,"
 Journal of Aesthetics and Art Criticism, Winter, 1964.

Novak, Barbara, American Painting of the Nineteenth Cen-
 tury. New York: Praeger, 1969.

Panofsky, Erwin, Early Netherlandish Painting. Cambridge:
 Harvard University Press, 1964.

_____. Meaning in the Visual Arts. Garden City:
 Doubleday, 1955. (Essays originally published between
 1921 and 1953.)

_____. Studies in Iconology. New York: Oxford Press,
 1939.

_____. "Wilhelm Voge; A Biographical Memoir," Art
 Journal, 1968.

Read, Sir Herbert, Icon and Idea. New York: Schocken
 Books, 1965. (First published in 1955.)

_____. The Meaning of Art. Baltimore: Penguin, 1963.
 (First published in 1931.)

Reynolds, Sir Joshua, Discourses on Art. New York: Col-
 lier Books. 1961. (Lectures delivered from 1769 to
 1790.)

Richardson, John Adkins and Ades, John I., "D.H. Lawrence
 on Cezanne: A Study in the Psychology of Critical In-
 tuition," Journal of Aesthetics and Art Criticism, Sum-
 mer, 1970.

Riegl, Alois, Die Spätrömische Kunstindustrie. Darmstadt:
 Wissenschaftliche Buchgesellschaft, 1964. (First pub-
 lished in 1901.)

_____. Stilfragen. Berlin: Schmidt, 1923. (First pub-
 lished in 1893.)

Robb, David, and Garrison, J.J., Art in the Western World.
 4th ed., New York: Harper and Row, 1963.

Rosenberg, Harold, The Anxious Object: Art Today and Its
 Audience. New York: Horizon, 1964.

Rothschild, Lincoln, Style in Art. New York: Thomas
 Yoseloff, 1960.

Sachs, Curt, The Commonwealth of Art. New York: W.W.
 Norton, 1946.

_____. The Commonwealth of Art, Washington: U.S. Printing Off., 1950. (A lecture delivered in 1949 at the Library of Congress.)

Schapiro, Meyer, "The Apples of Cezanne: An Essay on the Meaning of Still-Life," Art News Annual, 1968. (The Avant Garde. New York: Macmillan, 1968.)

_____. "The Liberating Quality of Abstract Art," Art News, Summer 1957.

_____. "Nature of Abstract Art," Marxist Quarterly, Jan.-March, 1937.

_____. "Style," Anthropology Today, Chicago, 1953. (Reprinted in Aesthetics Today, ed. Morris Phipson, Meridian, 1961.)

Smyth, Craig Hugh, Mannerism and Maniera. Locust Valley: J.J. Augustin, 1962.

Vasari, Giorgio, The Lives of the Most Eminent Painters, Sculptors, and Architects, tr. by Gaston du C. DeVere. 10 vols. London: Macmillan, 1912-14. (Originally published in Italian in 1550.)

Venturi, Lionello, Four Steps Toward Modern Art. New York: Columbia University Press, 1956.

_____. Paintings and Painters. New York: Charles Schribner's, 1945.

White, John, The Birth and Rebirth of Pictorial Space. London: Faber and Faber, 1957.

Wölfflin, Heinrich, Classic Art. New York: Phaidon, 1961. (Originally published in German in 1898.)

_____. Principles of Art History. New York: Dover Publications, 1932 etc. (Originally published in German in 1915.)

Worringer, Wilhelm, Abstraction and Empathy. Cleveland: World, 1967. (Originally published in German in 1908.)

_____. Form in Gothic. New York: Schocken Books, 1964. (Originally published in German in 1910.)

Zevi, Bruno, Architecture as Space. New York: Horizon
 Press, 1957.

Zupnick, Irving, "The Iconology of Style," Journal of Aes-
 thetics and Art Criticism, Spring, 1961.

Brand, *Sculpture in Stone*. New York: ... Press.

..., ... *The Technique of ...*: ... Art Institute ... Chicago Press, 1941.

INDEX

Ackerman, James v, 40, 101, 129, 144
Ades, John I. 47
Alberti, Leone Battista 7, 12, 24, 26
Amiens cathedral 25, 28, 110, 111, 113
Animal Head from Oseberg Ship-Burial; see Oseberg Ship-
 Burial
Arp, Jean 13-14, 13
Athena Lemnia 29, 30, 32, 90-91, 102-104

Beardsley, Aubrey 8-11, 9, 68
Berenson, Bernard v, 41, 42, 47, 123
Borromini, Francesco 25, 27
Bramante, Donato 24-25, 26
Brancusi, Constantin 21, 22
Braque, Georges 119, 120, 121
Brunelleschi, Filippo 12, 33, 115, 116, 122, 129

Castagno, Andrea del 137, 138
Chartres cathedral 25, 28, 29
Cimabue 140, 141, 144

David, Jacques Louis 27
Delacroix, Eugene 37, 39, 95
De la Tour, Georges; see Tour, Georges de la
Dipylon vase 58, 59, 66, 68, 70
Doryphorus, Frontispiece 32, 90

El Greco; see Greco, El

Florence cathedral 113, 116
Focillon, Henri v, 128
Francesca, Piero della 76, 79, 86-89, 98
Frankl, Paul 44, 97
Freedberg, Sidney J. 88, 90

Tour, Georges de la 56, 57
Turner, William 14-16, 15

Ulm cathedral 113, 114

Van Gogh; see Gogh, Vincent van
Vasari, Giorgio 32
Veneziano, Domenico 33, 34, 37
Veronese, Paolo 125, 126, 128, 143, 144
Victory of Samothrace; see Nike of Samothrace

Watson, John 77, 83, 95
Wölfflin, Heinrich v, 5, 7-8, 43-44, 47-48
Worringer, Wilhelm v, 48-49, 58-62, 64-66, 70, 102
Wren, Sir Christopher 115, 117, 118

Zevi, Bruno 17